30 Minutes

Painting Water
in Watercolour

Dedication

This book is dedicated to my wife,
Fiona Peart – every 30 minutes counts!

30 Minute Artist

Painting Water
in Watercolour

Terry Harrison

First published in Great Britain 2012

Search Press Limited
Wellwood, North Farm Road,
Tunbridge Wells, Kent TN2 3DR

Reprinted 2014 (twice)

Text copyright © Terry Harrison 2012

Photographs by Paul Bricknell at Search Press Studios

Photographs and design copyright
© Search Press Ltd 2012

ISBN: 978-1-84448-957-2

You are invited to visit the author's website:
www.terryharrison.com

Suppliers
If you have difficulty in obtaining any of the materials and
equipment mentioned in this book, then please visit the
Search Press website for details of suppliers:
www.searchpress.com

Printed in China

Acknowledgements

A big thank you to my favourite editor,
Sophie Kersey, for keeping an eye on the
clock and making sure this book reached its
deadline on time.
Also and equally, thank you to Fiona for
taking the time to correct and type the
words. Thanks to Paul, the photographer, for
capturing the step-by-step moments in time.

Contents

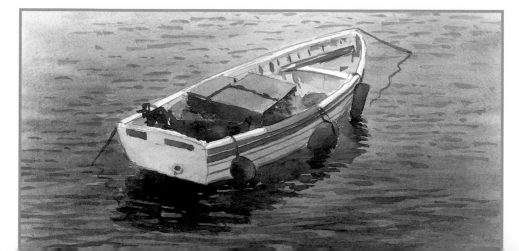

Introduction

Water, water everywhere – so why does it seem so difficult to paint? Water may at first appear rather complex, but in reality, it is fairly simple to paint; there are many easy techniques that will give you the impression of water in no time at all. In this book I help you understand and recreate the many moods of water, ranging from seas, streams, rivers and lakes to reflections, ripples and waves.

How times have changed; it seems that everyone wants everything right now – even artists apparently. Gone are the days when artists painted as a leisurely pastime, now all you have is 30 minutes to complete the painting, so ready, steady, paint... Watercolour painting could soon become an Olympic sport! I'm only joking, but seriously, if you have only a small window of opportunity to paint, don't take on something too demanding; keep it simple and not too large, and use my quick tips and techniques to help you. Painting quickly can loosen up your style and prevent your pictures from becoming too fussy and overworked. If this is what you would like to achieve, the quick exercises and step by step projects in this book will be ideal practice for you.

All of the step-by-step paintings in this book took less than 30 minutes to complete. My editor was also my timekeeper, but you don't have to be so hard on yourself and use a stopwatch – remember that painting is still a leisure activity and not a race against time.

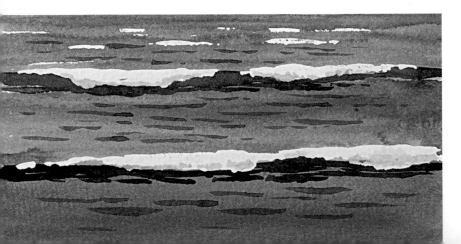

Opposite
This peaceful scene shows how reflections make water look wet. It features both wet into wet and wet on dry reflections.

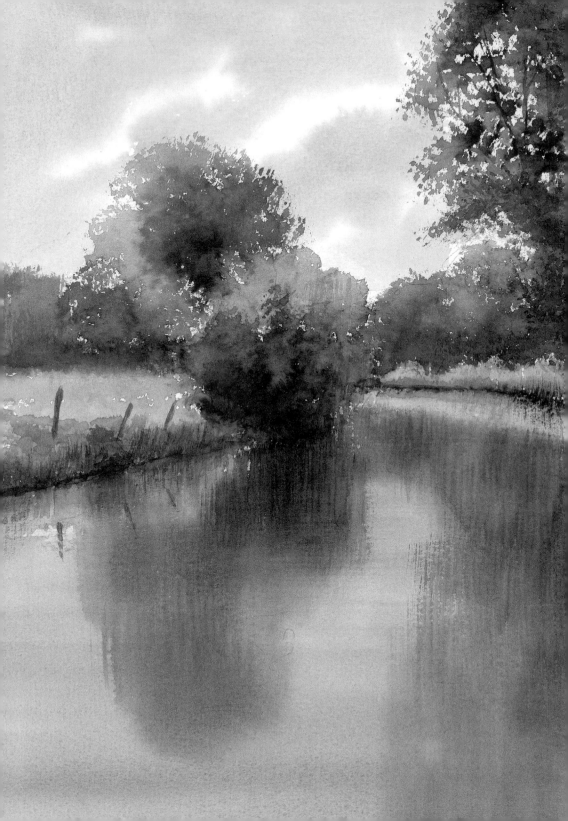

How to use this book

Half an hour is not a lot of time to paint a masterpiece, but I am sure you can, with a little preparation. There are one or two things to remember when tackling a painting in 30 minutes and the first and most important is size: don't paint too large – keep it small. All the paintings in this book were painted no larger than A4.

Next, keep it simple; you only have a little time, so choose your subject carefully and don't overcomplicate it.

The next step is preparation. Ensure you have everything you need to hand so that you can use all the techniques shown without having to stop to go and find things, mix more paint or change your water.

Carefully draw or plan your painting, and do not rush this bit. A poor drawing will end up a poor painting. Make sure you have a pleasing composition and a subject that excites you, and think about the colours and tones you will use.

Practise some of the subjects in the Quick techniques section before you begin the painting. As artists, we often don't practise enough. If you were a singer or a footballer, you would spend time practising your scales or skills before performing. I'm not suggesting you run around your studio before painting, but you may have a go at laying a watercolour wash, or painting some wet on dry brush strokes. Trying out these techniques will build your confidence and help you loosen up a bit, then with your newfound skills you will be able to tackle some of the ten projects with no fear at all. Once you have conquered the basic skills and projects, you will be able to move on and create your own compositions. Just remember, practise, prepare, then paint!

A graded wash

Wet the paper with a large wash brush – shown here is a 19mm (¾in) flat brush, and clean water. Pick up paint from the palette and paint with horizontal strokes, starting at the bottom. As you work up the area, the water on the paper will thin the paint, making the wash paler at the top. Allow to dry. This type of wash is very useful for painting water.

Wet into wet

Painting wet into wet creates a soft effect. While the underlying wash is still wet, pick up a slightly stronger wash on your brush and drop this into the first. Here this technique has been used to create soft-edged ripples.

Wet on dry

This technique is used to create harder lines and stronger brush strokes. Wait until the underlying wash is entirely dry, then paint on detail. Here the technique has been used to create strong, clear ripples.

Dry brush

This technique creates interesting textures and can be useful for suggesting fast-flowing water. Pick up paint on a 'thirsty' brush, which is damp, not wet. You can dry the brush a little on kitchen paper first. Drag the brush across the surface of Rough watercolour paper and it creates a speckled effect.

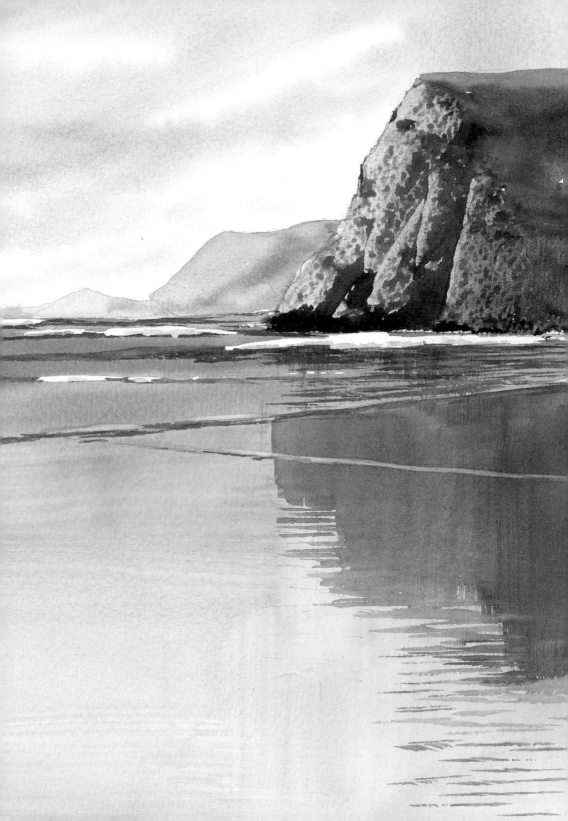

Materials

Brushes

I have my own range of brushes, specially designed to help you achieve the best painting effects with the minimum effort, and I have used these for the quick technique exercises and the step-by-step projects in this book. Of course you can use the brushes you already have, or choose ones with the attributes described below, to help you achieve the same effects.

The golden leaf brush holds lots of paint and is ideal for sky washes and for water.

The large, medium and small detail brushes are round brushes. The large one holds lots of paint and is good for washes, but it also comes to a fine point. The medium one is the workhorse of my brush range; it still holds quite a lot of paint but it is good for painting all but the finest details. The small detail, as its name suggests, is good for fine detail work.

The 19mm (¾in) flat brush is good for washes and also for painting larger ripples. The 13mm (½in) flat is useful for painting smaller ripples.

The foliage brush is useful for creating texture in a painting. The spring foliage brush is a larger version of this and is good for washes as well as texture.

Clockwise from left: spring foliage (or use a large wash brush), golden leaf (or use a wash brush or hog brush for texture), fan gogh (or use a hog fan brush), foliage (or use a 10mm/³/₈in one-stroke), wizard (or use a 10mm/³/₈in one-stroke), flat brushes, also available in other ranges, large detail (or use a no. 12 round), medium detail (or use a no. 8 round), masking fluid brush (or use an old brush), small detail (or use a no. 4 round), half-rigger (or use a rigger).

The fan gogh is thicker than most fan brushes and holds plenty of paint. It is very good for painting reflections and for fast-flowing water.

The wizard is made from a blend of natural hair, some of which is slightly longer than the rest. It is good for textured effects like fast-moving water, and for reflections.

The half-rigger has long hair and comes to a fine point, for very fine detail.

The white-haired brush is for masking fluid, but you can use an old brush if you coat it with soap before use.

Paints

Watercolour paints come in pans or tubes, and most people stick to whatever they started with. I prefer tubes as they are good for mixing large washes.

You can buy students' quality or artists' quality colours. I always use artists' quality colours because the results are so good, and with the students' quality you can end up using more of the paint to achieve the same colour, since they contain less pigment. It is advisable to buy the best paints you can afford.

When painting quickly, it is important to lay out your colours in your palette beforehand and mix up the washes you will need in the mixing wells, making sure you have plenty to keep you going before beginning to paint.

Paper

Watercolour paper comes in three surfaces, Hot Pressed (smooth), Not (cold-pressed or semi-smooth) and Rough. Rough paper is ideal for landscapes and for some of the textural effects you will need for water, such as the dry brush technique, because of its rough surface.

Paper also comes in different weights, and the lighter papers tend to cockle when wet, so if you are going to be using lots of wet washes, you either need to stretch the paper, or use a heavier paper. I have used 300gsm (140lb) Rough paper for all the paintings in this book, since this does not need stretching.

Other equipment

A hairdryer is used to speed up drying times, which is essential if you want to produce results in 30 minutes.

I use my trusty bucket as a water container, as this means I do not need to keep changing water during the painting process.

Masking fluid is used to mask areas that you want to keep white, such as the crest of a wave, and this is put into a dish if you are going to apply it with kitchen paper for textured effects. Soap is used to coat your brush before using masking fluid. This means the fluid washes off easily after use and does not ruin your brush.

A ruler is used to help you create a straight horizon when painting the sea.

A plastic card is used for the credit card rocks technique.

An eraser is to erase any mistakes.

Use a small coin to lift out the sun for a quick and effective technique.

A pencil is used for drawing.

Masking tape can also be used to create a straight horizon.

Colour

A lot can be achieved with just the primary colours and a limited palette. The colours shown on the right form my basic palette for painting landscapes, and I can mix all the colours I need from these.

I have a range of my own paint colours designed to simplify things for painters, and some of these appear in my basic palette. In this book I have used midnight green, country olive and sunlit green from my range when painting water, but if you don't have these, you can replace them with Hooker's green, olive green or green gold. I find that using ready-made greens prevents too many colours from appearing in one mix, which can lead to muddy colours. They are particularly useful when painting water, since you often need to mix blues and greens. Some useful colour mixes for painting water are shown below.

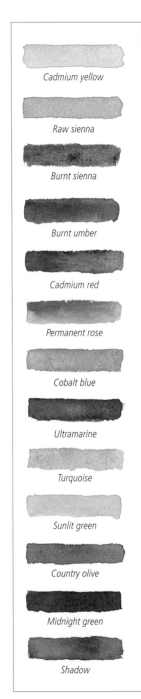

Cadmium yellow

Raw sienna

Burnt sienna

Burnt umber

Cadmium red

Permanent rose

Cobalt blue

Ultramarine

Turquoise

Sunlit green

Country olive

Midnight green

Shadow

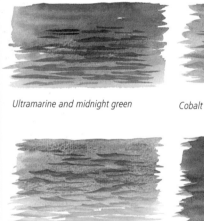

Ultramarine and midnight green

Cobalt blue and sunlit green

Cobalt blue and turquoise

Cobalt blue and midnight green

My shadow colour is useful for creating ripples, as well as shadows as its name suggests. If you do not have it, it can be mixed from cobalt blue, burnt sienna and permanent rose.

Cobalt blue

Permanent rose

Burnt sienna

A mix of all three colours, which can be used instead of my shadow colour.

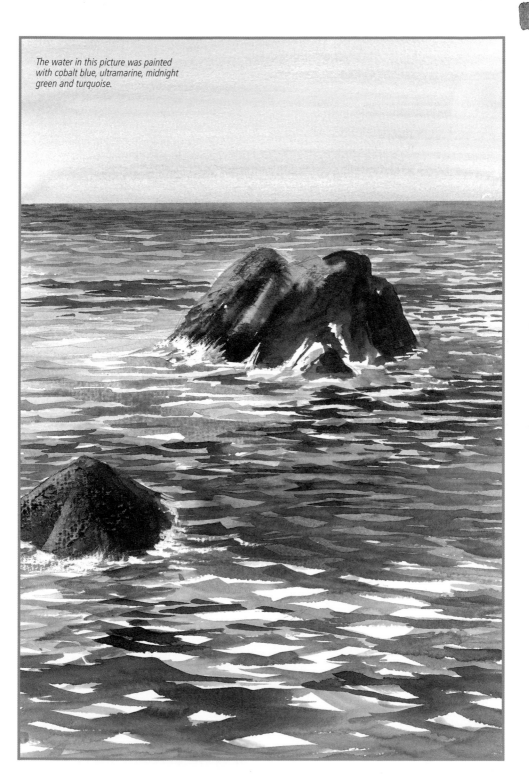

The water in this picture was painted with cobalt blue, ultramarine, midnight green and turquoise.

Quick techniques

Painting ripples

Using a flat brush is easier than using a round brush for this technique, and the ripples are best painted on a dry surface.

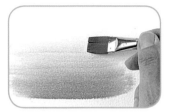

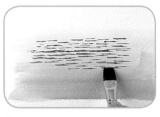

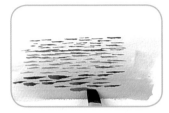

1 Wet the paper with a 19mm (¾in) flat brush and clean water, then paint on a wash of ultramarine, starting at the bottom of the area and working up with horizontal strokes. Allow to dry.

2 Use the 13mm (½in) flat brush and a stronger mix of ultramarine to make small, horizontal brush strokes in the background, coming forwards.

3 Make larger marks in the foreground, using a stronger mix of ultramarine.

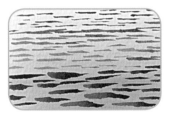

The finished ripples.

Lifting out ripples

This technique works best when the brush is slightly damp and the paper is dry. This is called a 'thirsty brush' and it is used to agitate the paint on the surface, after which the colour is lifted out using some kitchen paper.

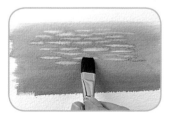

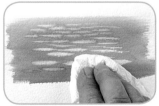

The finished ripples.

1 Wet the paper and paint an ultramarine wash exactly as above. Take a 13mm (½in) flat brush, wet it, then squeeze out the excess moisture so that it is just damp. Make brush strokes with the damp brush to disturb the paint, creating ripples.

2 Make larger ripples coming forwards. Use a piece of kitchen paper to lift out the colour.

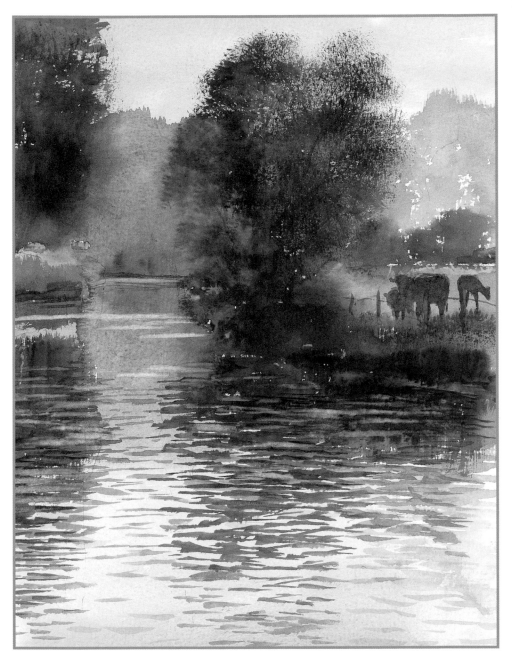

This painting combines both wet into wet and wet on dry techniques, and the lifting out method of painting ripples.

Reflections in still water

For a soft reflection, use the wet into wet technique.

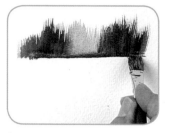

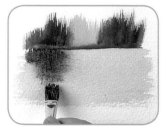

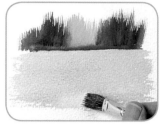

1 Use the wizard and country olive to paint the grasses at the water's edge, then add sunlit green for lighter parts and midnight green for darker parts. Allow to dry.

2 Stroke across a pale wash of ultramarine for the water, using horizontal strokes.

3 While this is wet, pick up the same greens as before and stroke them down into the water to create reflections.

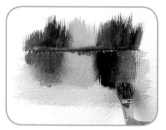

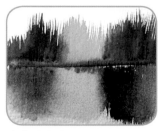

4 Continue dragging down greens wet into wet, using sunlit green in the middle and darker midnight green on the right.

The finished reflections.

Wet on dry reflections

This technique creates a crisper effect and mirror-like reflections.

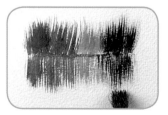

1 Use the wizard and country olive to flick up grasses.

2 Drag the reflection down below the waterline on the dry paper.

3 Continue, adding sunlit green and midnight green.

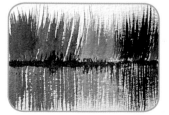

The finished reflection.

Opposite
The reflections in this painting were done with the wet into wet technique. To ensure that the brush is not overloaded with paint when you paint into the wet background, remove any excess by dabbing gently against some kitchen paper.

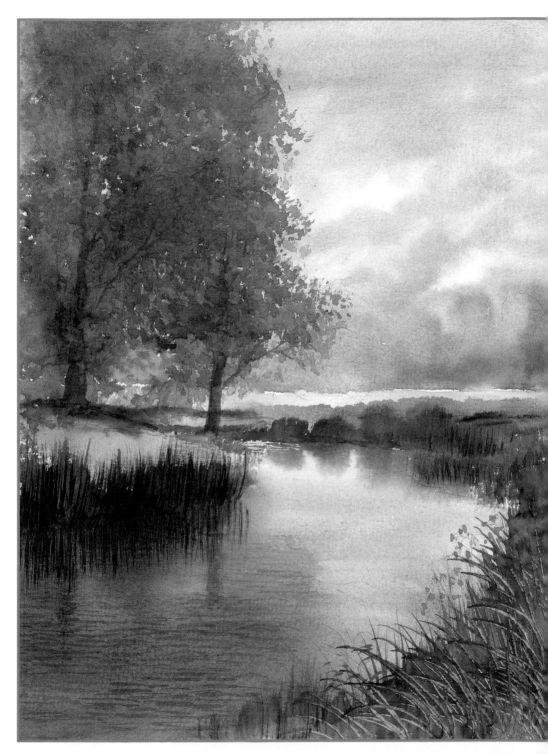

Puddles

This is a very simple shape with the reflection of the blue sky in the ellipse of the puddle.

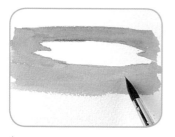

1 Paint round the puddle area with the large detail brush and a pale wash of burnt umber.

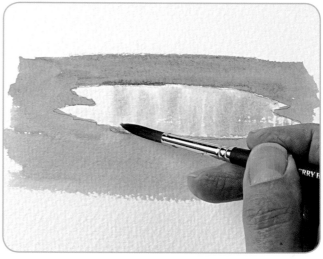

2 Wet the puddle area and use the medium detail brush to pull down a pale wash of ultramarine, leaving some white paper showing. This suggests a reflection of the sky.

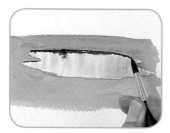

3 While the blue is wet, paint a line of darker burnt umber at the back of the puddle.

4 Pull down the burnt umber paint into the wet puddle to suggest that it is reflected.

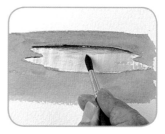

The finished puddle.

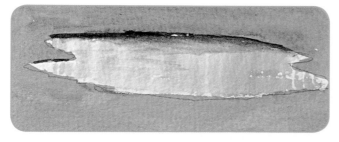

Opposite
The colour of the water in a puddle depends on what is reflected in it. If the puddle is in the open, the sky is reflected, whereas a puddle in a wood will of course reflect the trees overhead.

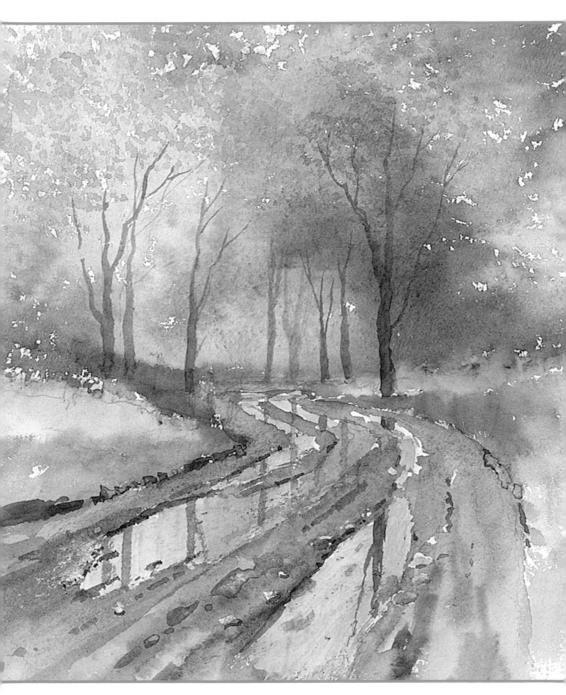

Rippled reflections

The flat brush works best for this technique, using the wet on dry method.

 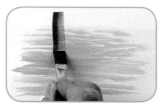

1 Wet the water area with the 19mm (¾in) flat brush and clean water. Paint on a pale mix of ultramarine with side to side brush strokes, suggesting ripples.

2 Load the 13mm (½in) flat brush with raw sienna on the right-hand side and burnt umber on the left, and drag down to paint a post.

3 Paint a second post in the same way.

4 Double-load the brush as before with raw sienna and burnt umber, and use the flat end to paint lines beneath the posts, suggesting reflections broken up by ripples. Make sure the reflections make a mirror image of the angles of the posts.

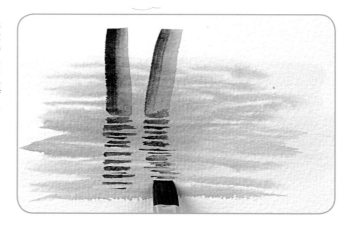

The finished rippled reflections.

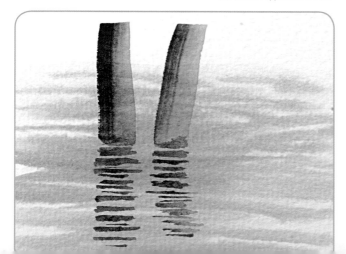

Opposite

A rippled reflection like this is created by movement on the surface of the water. To capture this effect, use a flat brush and paint the broken reflection with short horizontal brush strokes.

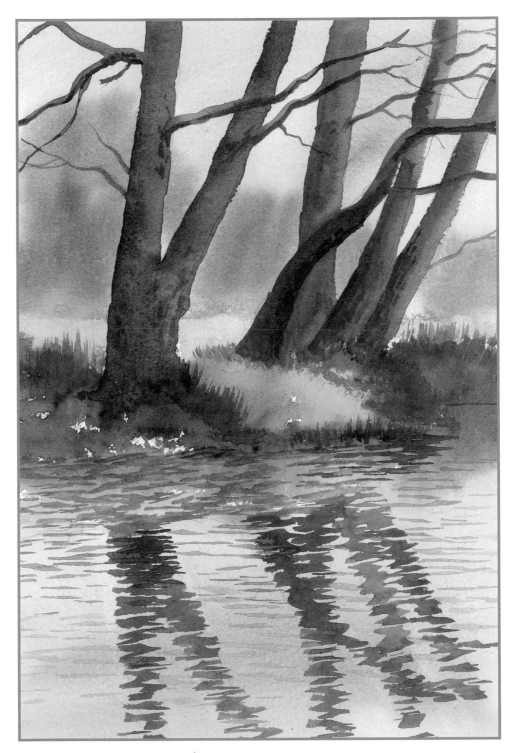

Waterfall

The texture and movement of a waterfall are best painted using the wizard brush on dry paper. The rocks are created using my credit card rocks technique.

1 Use the large detail brush to paint rock shapes with raw sienna, then while this is wet, paint a thick mix of burnt umber and ultramarine on top.

2 Scrape the edge of an old plastic card over the rocks. This technique scrapes off some of the top layer of paint and creates a rock-like texture. It works best on Rough watercolour paper.

3 Allow the rocks to dry, then mix ultramarine with a little burnt umber and use the wizard brush to stroke down the texture of the waterfall.

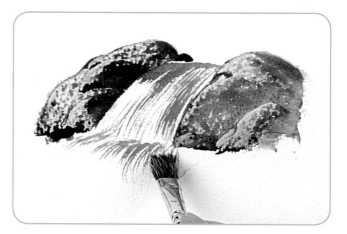

4 At the bottom of the waterfall, paint the water spraying out in different directions, using the wizard brush to create the texture.

The finished waterfall.

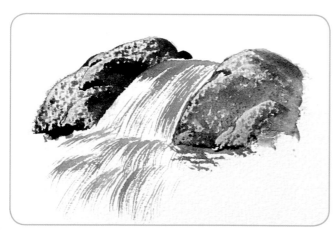

Opposite
To paint a waterfall like this, use minimal brush strokes. It is far too easy to overdo it and paint out all of the white paper. Use just the longer tips of the brush and draw it down in the direction and flow of the water.

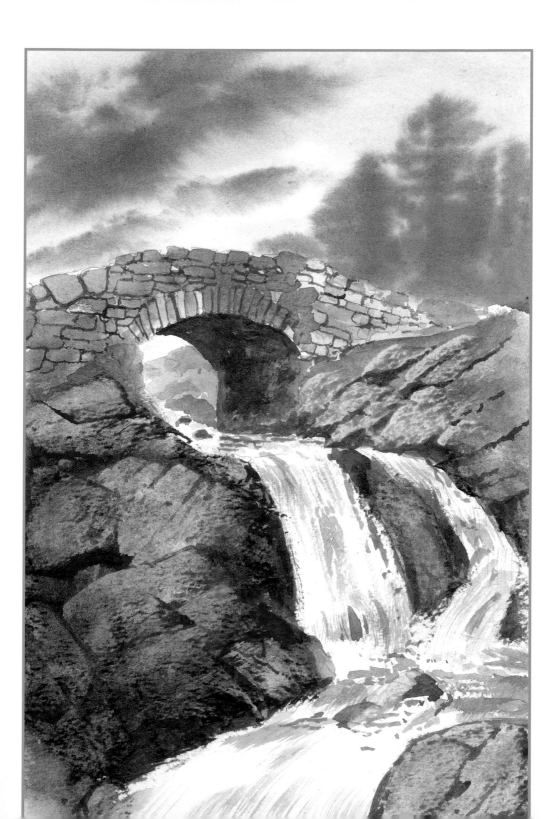

Fast-flowing stream

Create movement in your painting by adding some rapids using the dry brush technique.

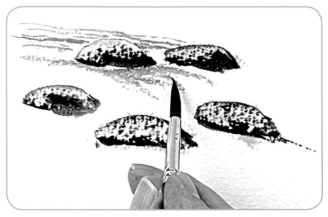

1 Paint rocks using the credit card technique shown on page 24.

2 Use the medium detail brush fairly dry with a mix of ultramarine to paint the texture of water flowing round the rocks. The dry brush technique will leave white paper and create a sparkle.

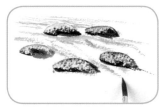

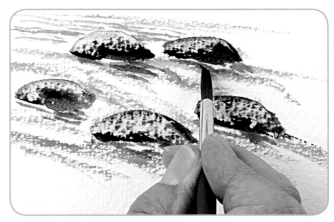

3 Continue painting with broader brush strokes at a different angle towards the foreground.

4 Paint broken reflections under the rocks with ultramarine and burnt umber.

The finished fast-flowing stream.

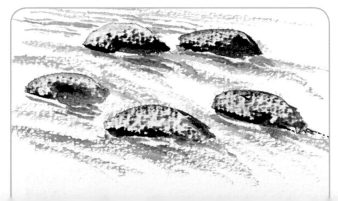

Opposite
The dry brush technique is excellent for capturing the sparkling, frothing effect of fast-moving water. Drag the brush over the paper surface and let the paint just catch the raised texture of the paper.

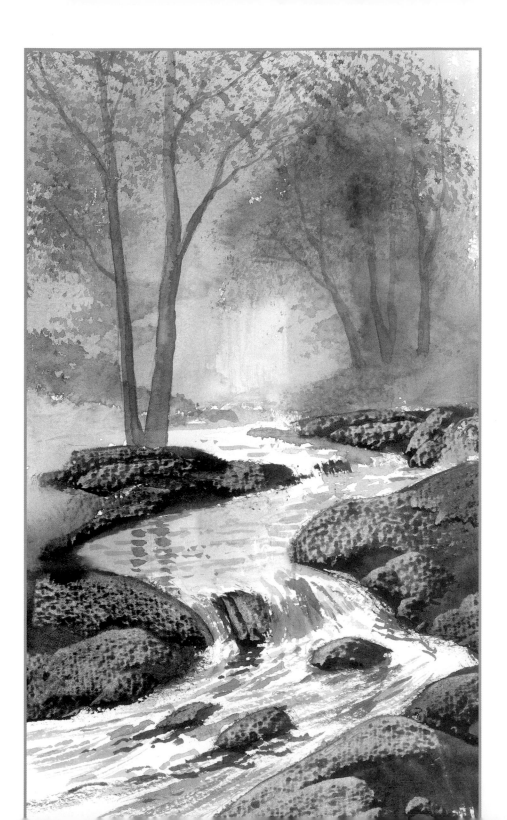

The sea from the beach

Use a ruler to steady your hand to paint the horizon. Leave some white paper to suggest distant breaking waves.

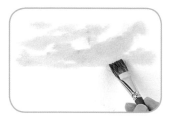 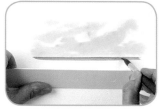 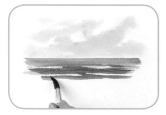

1 Use the spring foliage brush to wet the sky area, then paint a simple sky with a pale mix of ultramarine, leaving white paper for clouds.

2 Mix midnight green and ultramarine and use the large detail brush held against the edge of a ruler to paint the horizon.

3 Continue with horizontal strokes coming forwards, changing the colour to ultramarine and leaving white gaps for wave crests.

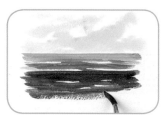 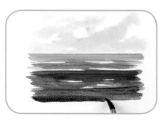

4 Add midnight green to the ultramarine and continue forwards, creating varied bands of colour and leaving streaks of white.

5 Paint the foreground with midnight green, leaving white paper for wave crests.

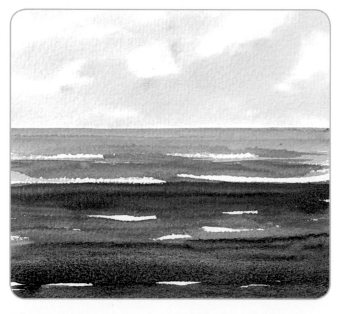

The finished sea viewed from the beach.

Opposite
Here the white of the cresting waves is suggested by leaving streaks of white paper unpainted. The sea is painted using horizontal brush strokes, and the surf on the beach is created by using masking fluid.

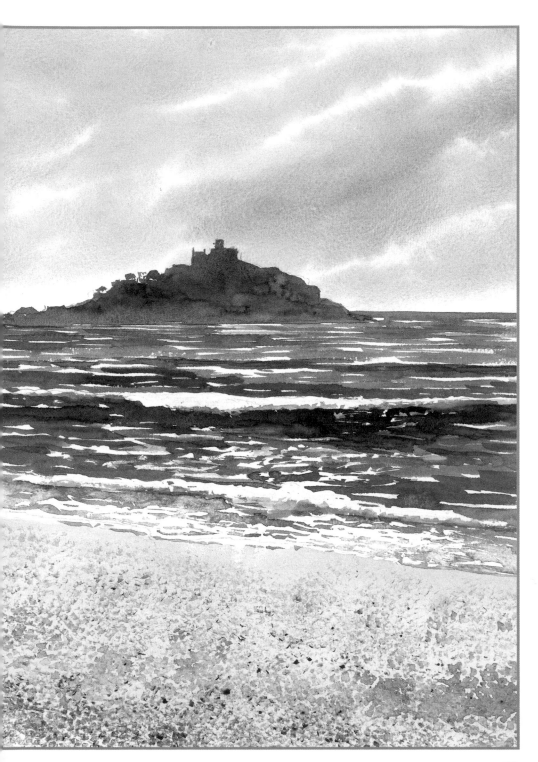

Breaking waves

Masking fluid is used to suggest the breaking waves in this technique.

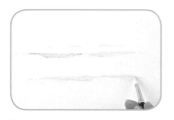

1 Paint masking fluid on the crests of the waves and allow to dry.

2 Use the large detail brush and a mix of midnight green and ultramarine to paint the horizon, holding the brush against the edge of a ruler to create the straight edge.

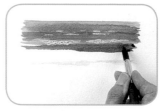

3 Come forwards in layers of colour, varying the blue/green mix and painting over the masking fluid. Allow to dry.

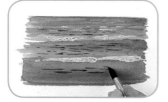

4 Make a darker mix of midnight green and ultramarine and use the tip of the brush to paint small ripples between the masked areas.

5 Use the same dark mix to paint shadow under the surf of the wave crests. Allow to dry.

6 Rub off the masking fluid with a dry finger. Use the small detail brush and a pale mix of cobalt blue to paint shadow and texture on the surf.

The finished breaking waves.

Opposite
In this painting the crests of the waves were masked, then a dark mix of blue and green was painted under this to suggest a shadow.

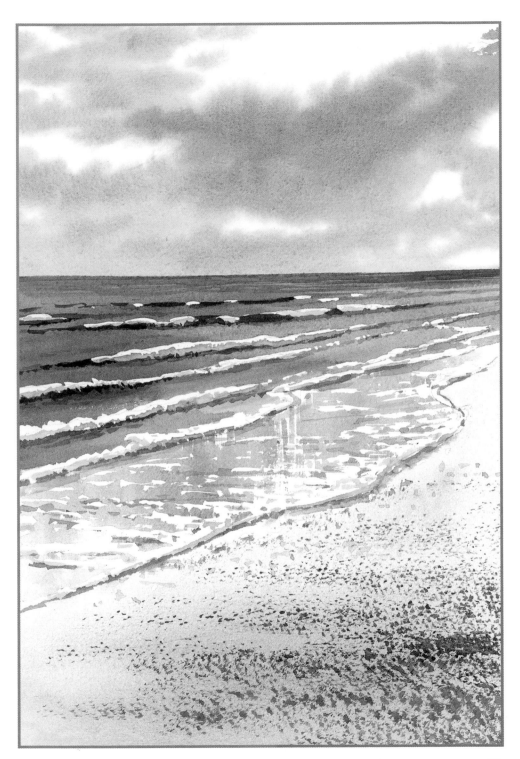

Painting choppy water

This wave pattern is created using a sweeping brush stroke, swaying from side to side.

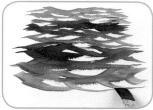
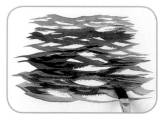

1 Mix ultramarine and midnight green and use the 13mm (½in) flat brush with sweeping, curved brush strokes, swaying from side to side, to create the effect of choppy, rippled water.

2 Move forwards, leaving some white paper for highlights and changing to the 19mm (¾in) flat brush in the foreground. Allow to dry.

3 Make a darker, stronger mix of ultramarine and midnight green and add further ripples on top of the dried paint.

The finished choppy water.

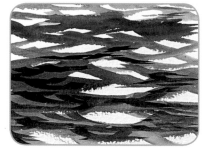

Lifting out choppy water

Here we create light ripples out of a dark colour using a thirsty brush.

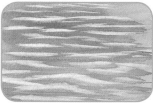

1 Mix turquoise and cobalt blue and paint a simple wash using the 19mm (¾in) flat brush, then paint ripples as above with a stronger mix of the same colours. Allow to dry.

2 Wet the brush then squeeze it out so that it is just damp, and use it to lift out colour, using the same side-to-side motion you used to paint the ripples. Blot with kitchen paper. Continue into the foreground.

The finished lifted out choppy water.

Opposite
This dynamic seascape is created with a combination of techniques. Masking fluid was used to suggest the pale blue swell in the troughs of the waves, and the darks were created using sweeping brush strokes.

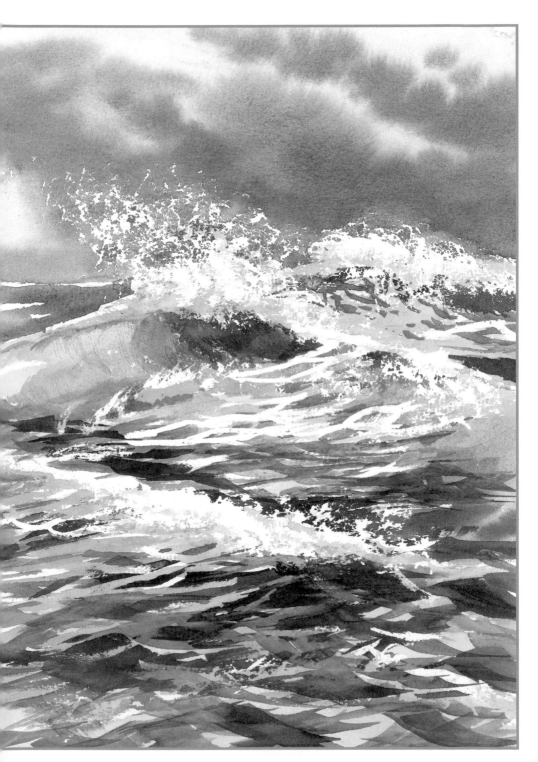

Crashing wave

Foaming water can be suggested by applying the masking fluid using kitchen paper.

1 Draw the wave first. Pick up masking fluid on scrunched up kitchen paper and dab this on to the foaming area of the wave to keep it white.

2 Use a brush to mask the areas of spume below the wave.

3 Mix ultramarine and midnight green and paint the sea behind the wave with the large detail brush.

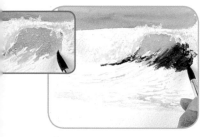

4 Paint the lighter part of the crest of the wave with turquoise, then the darker part with midnight green and ultramarine.

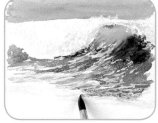

5 Mix cobalt blue with a little midnight green and paint the texture of the wave beneath the crest, going over the masking fluid.

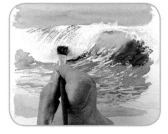

6 Paint the beach with raw sienna, then use the wizard with downward brush strokes for the water rolling over the wave, using cobalt blue and midnight green.

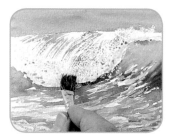

7 Paint a pale mix of cobalt blue over the masking on the wave crest. Allow to dry.

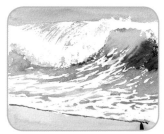

8 Rub off the masking fluid. Use the large detail brush to paint the shadow under the surf with burnt umber. After this, add texture to the foam using cobalt blue.

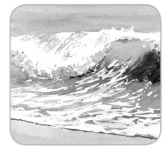

The finished crashing wave.

Opposite
When I think of waves, I imagine a cresting wave like this, rising then rolling over and crashing into the surf on the beach.

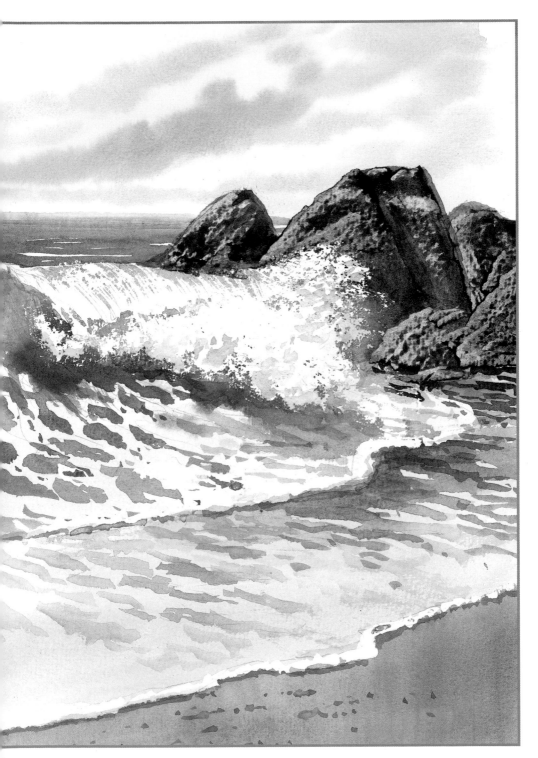

Wave breaking on rock

Two techniques are used here: masking fluid is used to suggest the spray whilst the rock is created by using the credit card technique.

1 Draw the scene. Apply masking fluid on kitchen paper to mask the foam, then use a brush to mask the edge of the surf.

2 Use the large detail brush to wet the sky area, then paint stormy clouds with ultramarine and burnt umber, over the masked foam.

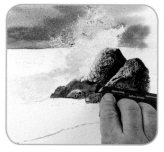

3 Paint and scrape out the rocks using the credit card technique shown on page 24.

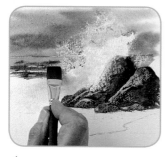

4 Use the 19mm (¾in) flat brush and midnight green and ultramarine to paint the distant water, then paint wave shapes with a stronger mix.

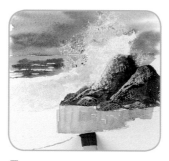

5 Make a thin mix of burnt umber and ultramarine and drag down reflections under the rocks. Continue to the left with a bluer mix.

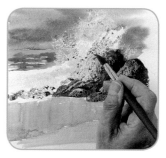

6 Use the large detail brush to paint the beach with raw sienna, then paint texture in the foam over the masking fluid with a strong mix of cobalt blue. Allow to dry.

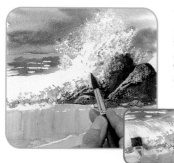

7 Remove the masking fluid and paint more cobalt blue texture into the white foam. Change to the wizard and paint the water rolling over the wave with a mix of midnight green and ultramarine.

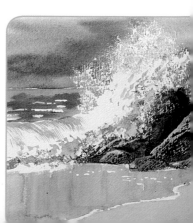

The finished wave.

Here the light ripples in the swell were created by lifting these areas once the dark section had dried. White gouache was used to suggest the foreground rivulets of water on the rocks.

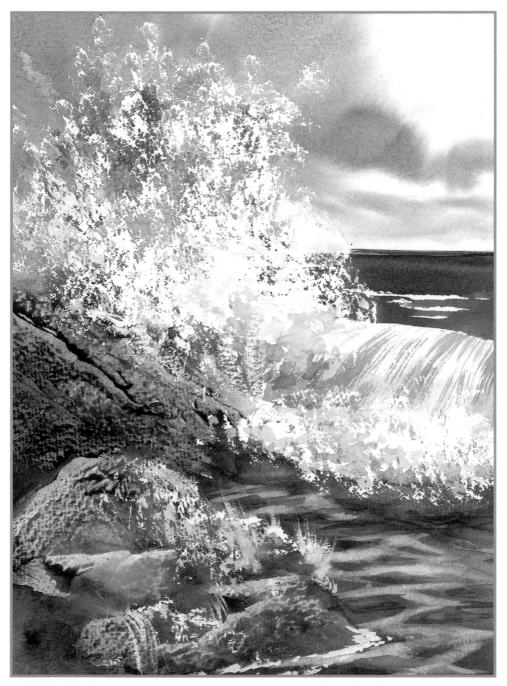

Beach with surf

The reflection of the cliff on the beach is broken up by the surf lines which are created using masking fluid at the start of the painting.

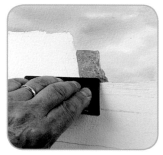
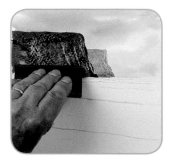

1 Draw the scene and mask the surf with a brush and masking fluid. Use the wizard to wet the sky area, then paint it with raw sienna. Paint in clouds with ultramarine, wet into wet. Allow to dry.

2 Paint the distant cliff with the large detail brush and a pale mix of ultramarine and burnt umber, then use a plastic card to scrape out texture.

3 Paint the nearer cliff with a stronger mix, then scrape out texture with a card in the same way.

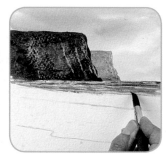
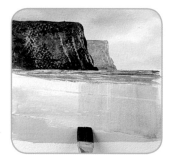

4 Use a mix of ultramarine and midnight green and a side-to-side motion of the brush to paint the sea.

5 Paint the beach with raw sienna and a little burnt sienna. Wet the area between this and the sea and use the 19mm (¾in) flat brush to stroke down a pale mix of ultramarine to suggest wet sand.

6 Stroke down a strong mix of ultramarine and burnt umber below the cliff, and a paler mix below the more distant cliff to create reflections in the wet sand. Allow to dry and remove the masking fluid.

The finished beach.

Opposite
The large expanse of foreground is made interesting by the surf line and the ripples, which were created using masking fluid.

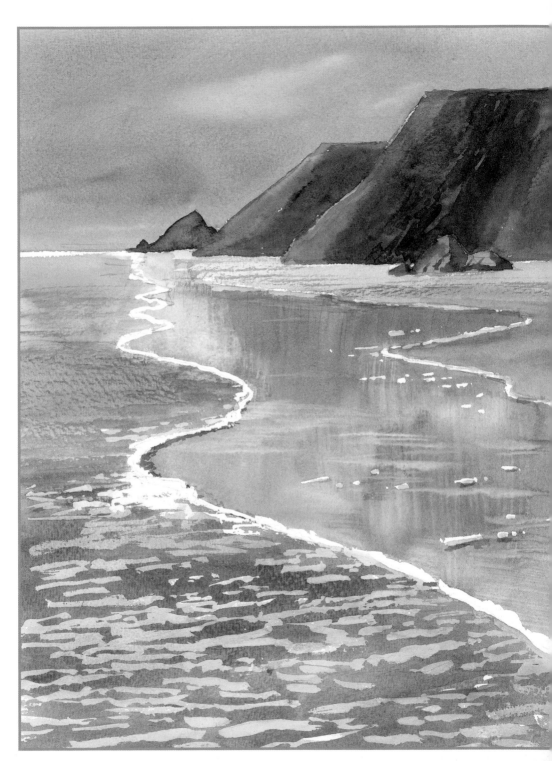

Masking the horizon

Masking tape can be a great tool to use when painting straight lines such as the horizon. Use low tack tape and gently apply this to the paper, ensuring it is horizontal.

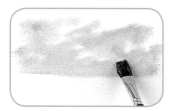

1 Wet the sky area with the wizard and paint in raw sienna, then ultramarine wet into wet. Allow to dry thoroughly.

2 Carefully place masking tape over the bottom of the sky to create a straight line for the sea horizon. Rub the masking tape to make sure it is properly adhered.

3 Paint the sea over the edge of the masking tape with a mix of midnight green and ultramarine and the large detail brush. Allow to dry.

4 Take great care when removing the masking tape so as not to tear the paper.

Opposite
The horizon of this painting was done using the masking tape technique.

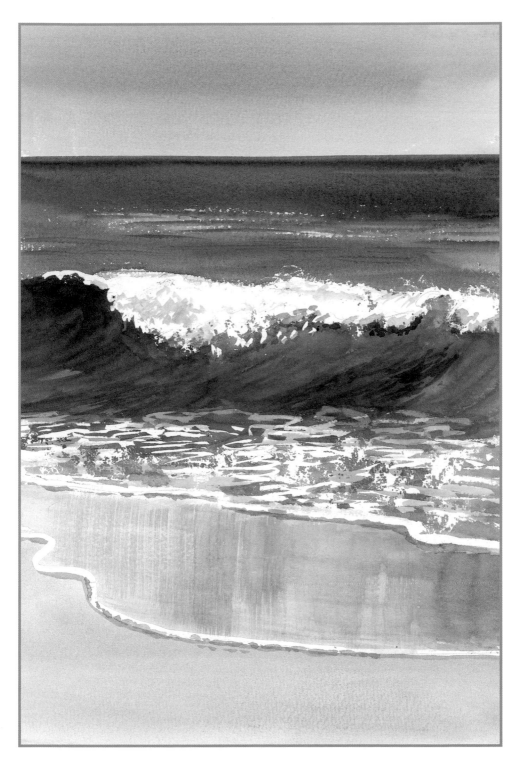

Sunset on the sea

A coin wrapped in kitchen paper is pressed against the wet paper surface to lift the colour and suggest the sun, and sunlight on the water is created using masking fluid.

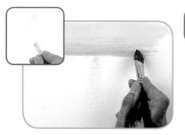

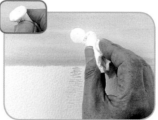

1 Mask the sparkled reflection of the sun on the water with side-to-side brush strokes, using masking fluid. Wet the sky area with the spring foliage brush then paint the sky with cadmium yellow. Paint near the horizon with cadmium yellow and permanent rose.

2 Wrap a small coin in a double layer of kitchen paper. Press this into the wet paint to lift out colour for the sun, making sure you place it directly above the masked reflections.

3 Paint cadmium yellow around the masked reflection on the sea.

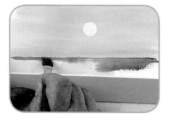

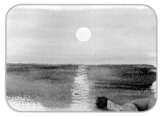

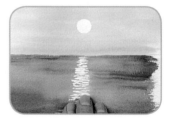

4 Make a dark mix of shadow and permanent rose. Prop a ruler against your finger and run the spring foliage brush along it to paint the mix on to the horizon.

5 Paint the dark sea colour over the masked sparkles and the cadmium yellow band.

6 Allow the painting to dry, then rub off the masking fluid with clean fingers.

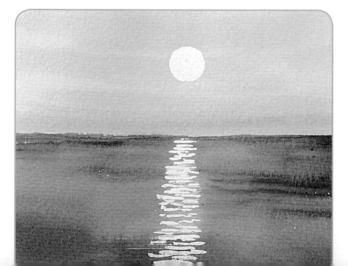

The finished sunset.

Opposite
In this painting, in addition to the techniques shown here, I have added dark ripples either side of the light reflection on the water, using a small detail brush and short horizontal brush strokes.

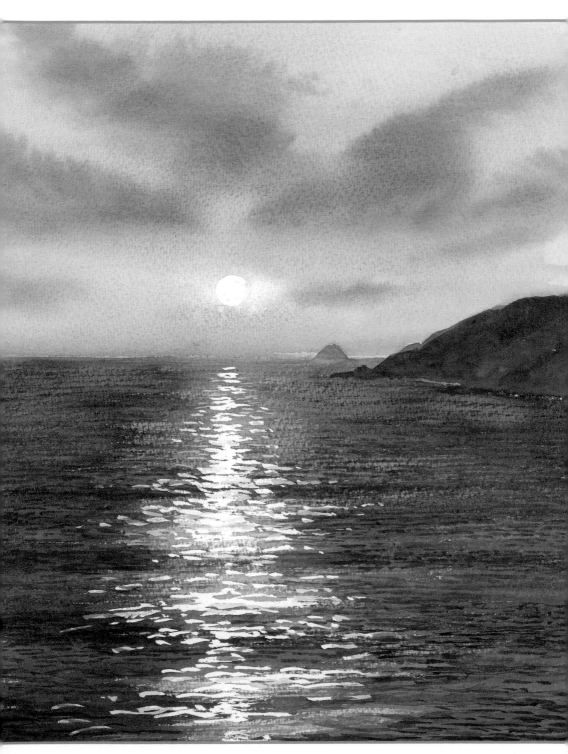

Bridge

This is an easy way to paint a bridge and its reflection; you treat the reflection in the water almost as a mirror image.

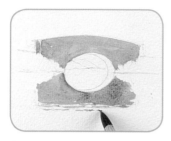

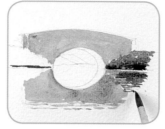

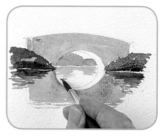

1 Draw the scene. Use the large detail brush and a mix of raw sienna and burnt sienna to paint the bridge and its reflection. Break up the reflection into ripples at the bottom.

2 Paint the waterline and the greenery on the banks with the medium detail brush and country olive. Paint the reflection below, breaking it up and leaving white paper for ripples.

3 Make a paler mix of country olive and paint the distance in the arch of the bridge, and the reflection below. Break up the reflection, leaving white ripples as before.

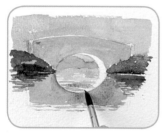

The finished reflection.

4 Paint the sky with ultramarine and the reflection in the arch of the bridge, leaving white paper as before. Allow to dry.

5 Use the small detail brush and a mix of ultramarine and burnt umber to paint the dark shadow under the bridge, then paint the reflection with short, horizontal brush strokes, leaving a little white paper.

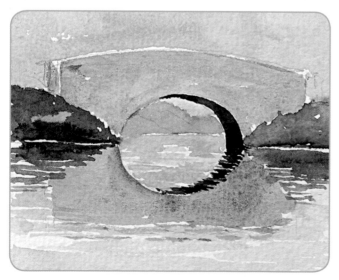

Opposite
When painting a bridge like this, paint the reflection at the same time as the bridge and with the same paint mix. This will save you trying to mix the same colour twice. Masking fluid was used to suggest ripples under the bridge, which helps to break up the reflection and adds movement to the water.

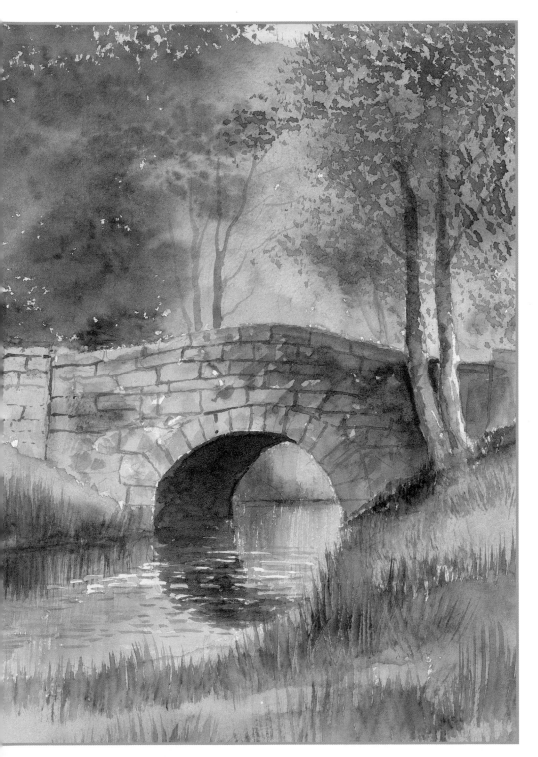

Building and reflection

Only if the water is right up to the edge of a building, as in a flood, is the image in the water a mirror image. Paint what you see, not what you think you see.

1 Draw the scene. Use masking fluid and a brush to mask the light in the window, the lamp and their reflections. Allow to dry, then use the spring foliage brush to paint raw sienna over the scene.

2 While this is wet, paint from the bottom and from the top of the painting with ultramarine, blending in to the raw sienna. Dry.

3 Wet the whole scene with clean water, then paint a dark mix of ultramarine and burnt umber from the top down, then from the bottom up. Blot with kitchen paper in the middle. Dry.

4 Paint the house on the right and the right-hand side of the other building with the small detail brush and a grey mix of ultramarine and burnt umber. Use the 13mm (½in) flat brush to drag down a reflection, then break this up with ripples.

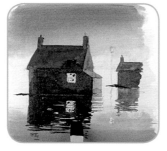

5 Use the medium detail brush and a dark mix of the same colours to paint the main building, then use the 13mm (½in) flat brush to drag down a reflection. Break this up as before.

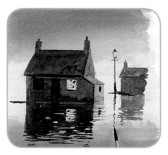

6 Paint the architectural details and the lamp post with the small detail brush and the dark mix, then paint a rippled reflection with a wiggle of the brush.

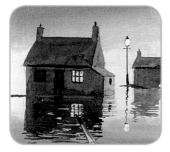

7 Rub off the masking fluid and paint the window and reflection with cadmium yellow. Allow to dry, then paint the window frame with ultramarine and burnt umber.

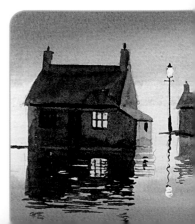

The finished building and reflection.

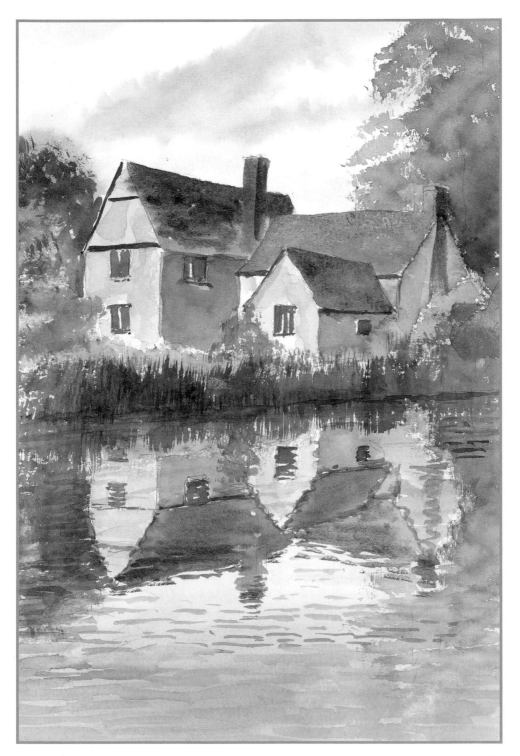

Riverbed

This is a simple and effective way of lifting out pebbles and stones.

1 Draw the pebbles first. Use the large detail brush and raw sienna to paint over the area shown, then paint horizontal strokes of burnt sienna wet into wet.

2 Still working wet into wet, paint ultramarine over the water area. Allow to dry.

3 Paint a wash of burnt umber with broad, horizontal strokes.

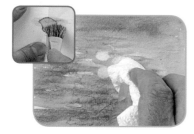

4 Make a paper mask from scrap paper and tear a hole the size of a pebble. Place the mask over the painting, dab over the hole with a damp foliage brush and blot with kitchen paper to lift out colour.

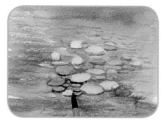

5 Continue, lifting out colour from some of the pebbles using different sized holes in the paper mask. Use the medium detail brush and burnt umber to paint shadows and suggest form, fading to a paler mix in the background.

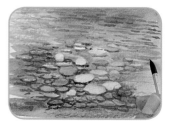

6 Paint ripples on the water with ultramarine.

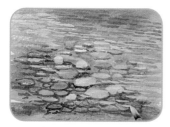

7 Mix white gouache with a little ultramarine and paint light ripples over the water and the underwater pebbles.

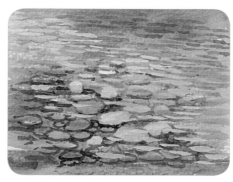

The finished riverbed.

Opposite
The stones and rocks on the riverbed are clearly visible through the shallow water at the river's edge. As the water gets deeper, the rocks fade into the reflection on the surface of the river.

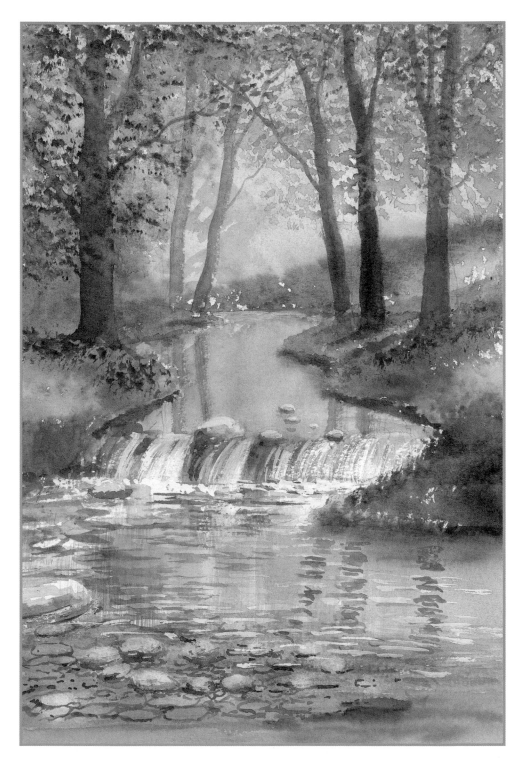

Marsh

The soft misty background trees and sky are best painted wet into wet and the reflection should be painted at the same time using the same colours.

1 Wet the paper with the spring foliage brush, leaving a dry line at the water's edge. Paint a graded wash of ultramarine from the top, allowing the paint to become more diluted down to the white line. Then start at the bottom and paint up to the white line in the same way.

2 Use the wizard to paint the distant trees, working wet into wet with a mix of midnight green and ultramarine, fading down to the dry white line.

3 While the paper is still wet, drag down the reflection in the water with a slightly paler mix.

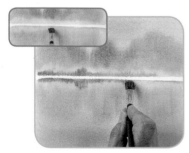

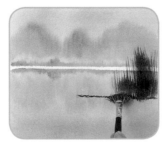

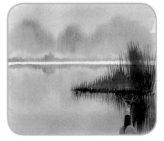

4 Working wet into wet, paint raw sienna at the base of the trees, and in the reflection. Paint country olive along the waterline and reflection, wet into wet.

5 There is an area of reeds and grasses in the foreground. Use the fan gogh and midnight green to paint the waterline of this area, then stroke up the grasses.

6 Drag down the same paint mix to create reflections of the grasses, then pick up burnt umber on the end of the brush and darken the waterline.

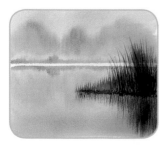

7 Use the half-rigger and midnight green to paint reeds and grasses, and their reflections beneath.

The finished marsh.

Here the water is still and the trees and reflections are soft and misty, in sharp contrast to the foreground reeds. The crisp, clear foreground against the out-of-focus background suggests distance in the painting.

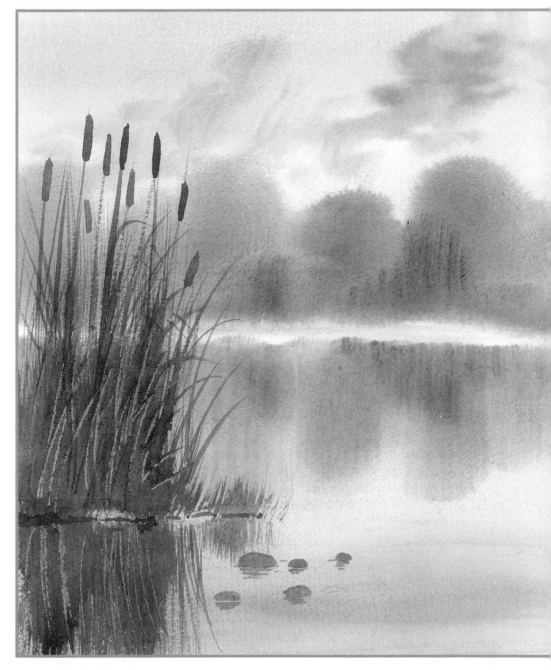

Boat

Each section within this exercise is painted separately, but a hairdryer can be used to dry the stages to speed up the process.

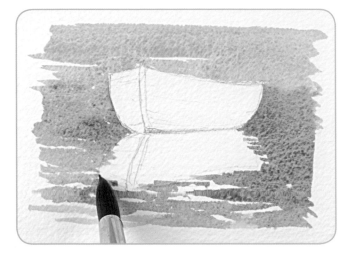

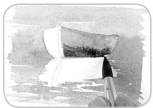

2 Paint the boat with raw sienna and burnt sienna, then drop in burnt umber at the bottom, wet into wet.

1 Draw the boat and reflection or trace and transfer them from this page. Paint a wash of ultramarine using the large detail brush around the boat and reflection. Leave white paper for ripples beneath the boat.

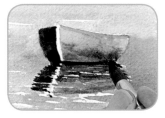

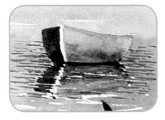

3 Paint a broken reflection below the boat with the same mix, then add raw sienna for the bottom of the reflection.

4 Use a dark mix of ultramarine and burnt umber to paint the left-hand side of the boat and the waterline, then paint a reflection, broken up into ripples. Allow to dry.

5 Paint horizontal strokes for ripples all around the boat with the medium detail brush and ultramarine.

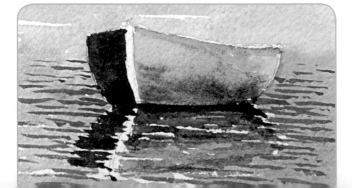

The finished boat.

The reflections of the boats are just as important as the boats themselves. Reflections on rippled water are easy to paint, just repeat the colours and shapes you see in the boats using short horizontal brush strokes.

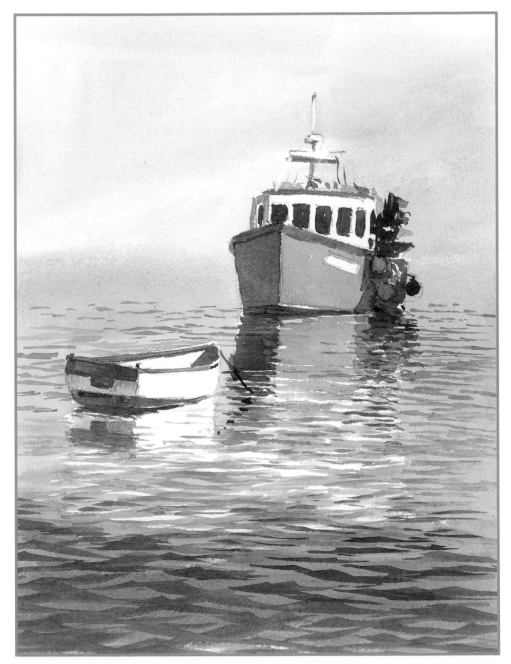

Sky reflections

This is like painting two skies in one painting; only one is a reflection in the water on the beach.

1 Wet the paper with clean water and use the spring foliage brush to paint raw sienna at the bottom of the sky and the top of the reflection on the beach.

2 While the first wash is wet, paint ultramarine at the top of the sky and the bottom of the reflection.

3 Still working wet into wet, paint clouds with ultramarine and burnt umber and their reflections below. Allow to dry.

4 Paint the horizon with a pale mix of the same colours, using the medium detail brush and a ruler as shown on page 42.

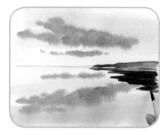

5 Use lighter and darker mixes of the same colours to paint the land on the right.

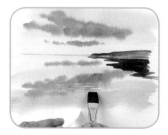

6 Wet the 19mm (¾in) flat brush and squeeze it out so that it is just damp. Use it to lift out ripples in the water, and blot them with kitchen paper.

The finished sky reflections.

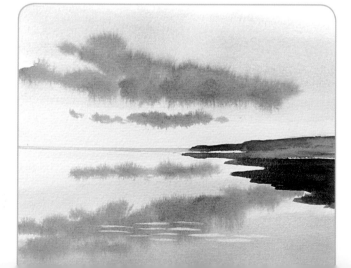

Opposite
For the sand to appear wet, the same colours used for the clouds are painted for their reflection but downward brush strokes are used to suggest the water's sheen.

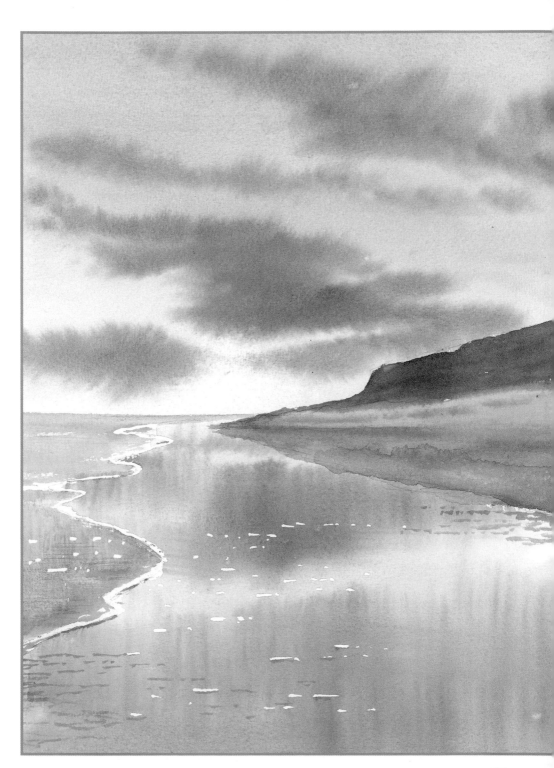

Projects

Track with Puddles

This woodland track needs some extra interest, and adding puddles provides it. When painting puddles, try where possible to have something reflected in the water, such as a tree or a fence post; this will help make the water appear wet. Masking the track helps to retain the shapes of the puddles.

You will need

Masking fluid and brush
Brushes: spring foliage, 13mm (½in) flat, medium detail, large detail, fan gogh, foliage, half-rigger, small detail
Colours: cobalt blue, sunlit green, cadmium yellow, raw sienna, midnight green, country olive, burnt umber, shadow, burnt sienna, white gouache

1 Draw the scene first. The drawing stage is not included in the 30 minutes, so take your time. Mask the track with masking fluid and a brush. Allow to dry.

2 Use the spring foliage brush to paint cobalt blue into the distance suggesting sky beyond the trees. Stipple sunlit green and cobalt blue on top.

3 Stipple cadmium yellow for the lighter area of the trees, then stipple darker foliage with cobalt blue and sunlit green. These stippling stages should be done fairly quickly.

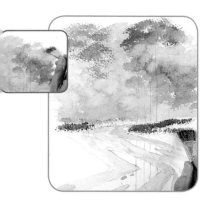

4 Stipple a little raw sienna and sunlit green at the top right-hand side of the trees. Make a stronger mix of midnight green and country olive and stipple this over the foliage and the ground.

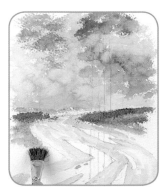

5 Mix raw sienna and burnt sienna and stipple this on the ground coming forwards.

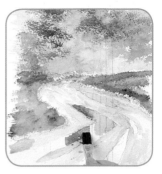

6 Stipple more midnight green and country olive on to the ground, then add this darker tone to the trees. You should be about ten minutes into the project as you finish the initial stippling of foliage and ground.

7 Take the 13mm (½in) flat brush and drag down reflections of the background colours in the puddles, starting with cadmium yellow.

8 Mix cobalt blue and cadmium yellow and drag down these colours in the puddles.

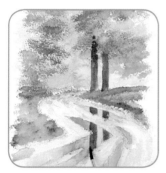

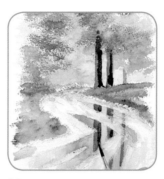

9 Use the medium detail brush and a mix of country olive and burnt umber to paint the two tree trunks on the right, and their reflections.

10 Use a darker mix of the same colours to shade the right-hand sides of the trunks, and repeat in the reflections.

11 Add branches and twigs with a paler mix, then paint the trunks and finer branches on the left, and their reflections. Allow to dry.

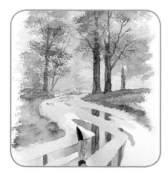

12 Remove the masking fluid. Paint the track with the large detail brush and raw sienna.

13 Mix burnt sienna and burnt umber and paint this on the track wet into wet to create texture.

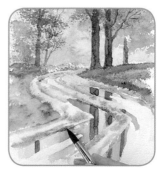

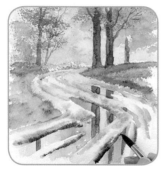

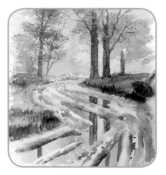

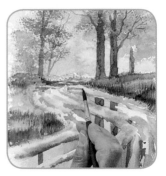

14 Shade the edges of the track along the water's edge with shadow and burnt umber. Around twenty minutes should have passed since you started.

15 Use the fan gogh brush and country olive to flick up grasses on either side of the track.

16 Change to the medium detail brush and use a mix of cobalt blue and shadow to paint distant shadows from the trees across the track.

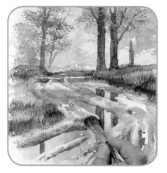

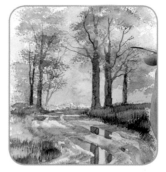

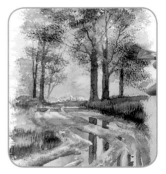

17 Continue into the middle ground with another shadow across the track, then use the foliage brush and a mix of burnt sienna and shadow to stipple texture in the foreground.

18 Use the half-rigger and a mix of country olive and burnt umber to paint more branches.

19 Stipple more midnight green and country olive over the foliage using the spring foliage brush.

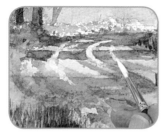

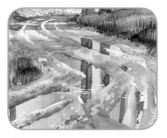

20 Add highlights to the puddle water with the small detail brush and white gouache.

21 Paint ripples in the foreground in the same way. Time's up! If all goes well, this project is achievable, from applying masking fluid to this last stage, in half an hour.

Opposite
The finished painting.

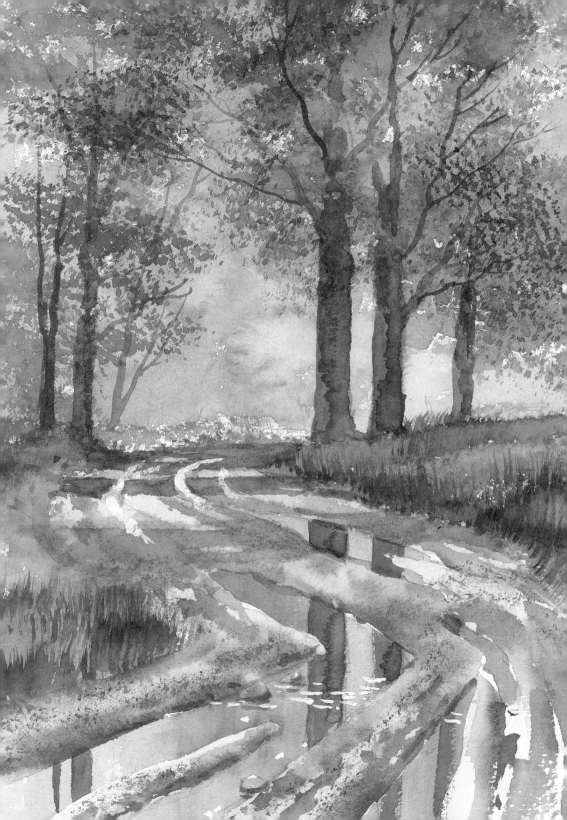

Ford

A ford is water crossing at a shallow place. Most have a footbridge for pedestrians, which is great if you are looking for a subject to paint. To make the water appear wet, choose a viewpoint from which you can see some trees or the bridge reflected in the water. Painting ripples on the stream will help to break up the reflections and give the impression of movement.

You will need

Masking fluid and brush
Scrap paper for paper mask
Brushes: spring foliage, medium detail, 13mm (½in) flat, small detail, wizard, fan gogh
Colours: cadmium yellow, cobalt blue, sunlit green, country olive, raw sienna, burnt sienna, shadow, midnight green, ultramarine, burnt umber

1 Draw the scene first. Your 30 minutes start once the drawing is done.

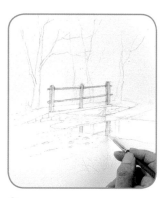

2 Mask the posts and their reflection, ripples under the ford and pebbles with masking fluid and a brush.

3 Use the spring foliage brush to paint a pale mix of cobalt blue in the foliage behind the ford, then paint cadmium yellow on either side.

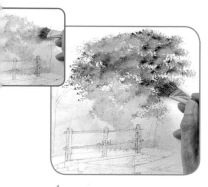

4 Stipple sunlit green in the foliage on the right, then stipple country olive on top, while this is wet.

5 Make a pale mix of cobalt blue and cadmium yellow and stipple this over the foliage background. Use a paper mask to mask the ford and stipple strong country olive and midnight green to create undergrowth behind it.

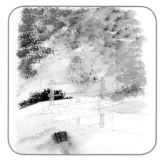

6 Stipple more of the dark green over the foliage area. Paint a wash of raw sienna over the ground, then stipple raw sienna and burnt sienna for texture.

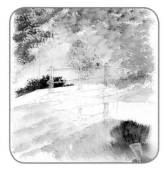

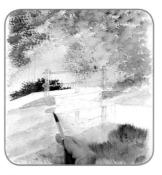

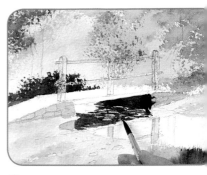

7 Paint sunlit green in the foreground and then flick up grasses with country olive. Around ten minutes should have elapsed since you started.

8 Use the medium detail brush and a pale grey mix of ultramarine and burnt umber to paint the stone of the ford and its reflection.

9 Paint the dark under the ford with a mix of ultramarine and burnt umber, then paint its reflection, leaving white paper to suggest a broken, rippled reflection.

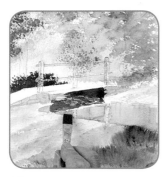

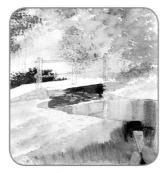

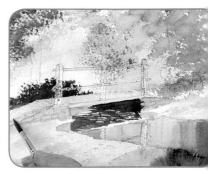

10 Use the 13mm (½in) flat brush to drag down reflections of the background, beginning with cadmium yellow and a little cobalt blue.

11 Add a darker reflection of cobalt blue and sunlit green.

12 Use the medium detail brush and a pale mix of raw sienna to paint the footpath over the ford. Dry.

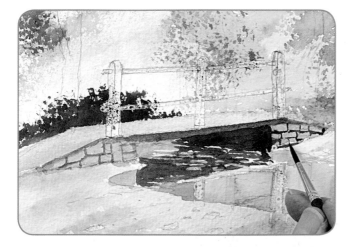

13 Make a dark mix of burnt umber and ultramarine, though not as dark as the shadow under the ford. Paint the shadowed side of the ford, and the crevices and shadows on the stonework, using the small detail brush.

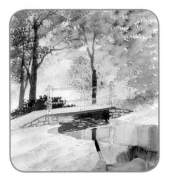

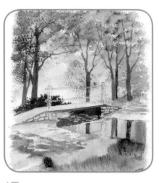

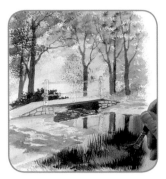

14 Paint the tree trunks and branches with the medium detail brush and country olive and burnt umber, then paint their reflections in the water. You should be about twenty minutes into the project now.

15 Change to the wizard brush and use the colour shadow to paint shadows across the track in the foreground.

16 Use the fan gogh to flick up grasses with country olive.

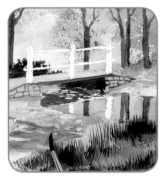

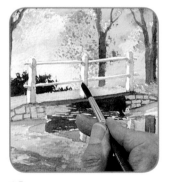

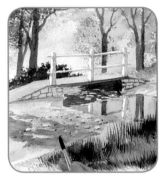

17 Allow to dry and remove all the masking fluid with clean fingers. Use the medium detail brush and raw sienna to soften the masked pebbles.

18 Mix pale cobalt blue with a touch of burnt sienna and paint the shaded parts of the posts, and their reflections.

19 Use a dark mix of the same colours to paint the shadows under the stones on the path.

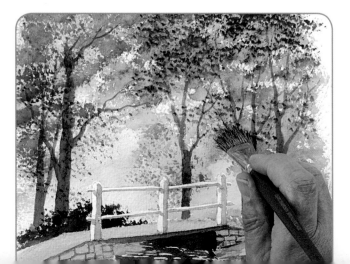

20 Darken the foliage by stippling on a mix of midnight green and country olive with the spring foliage brush.

Opposite
The finished painting.

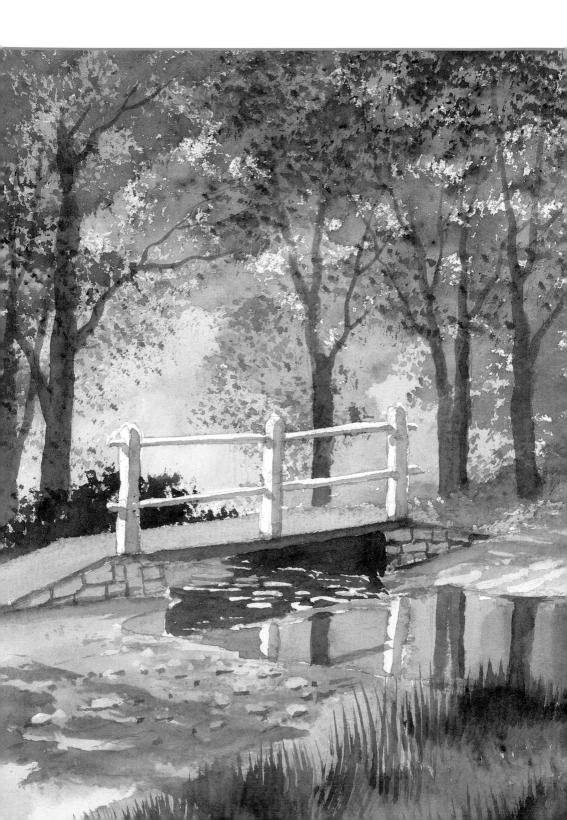

Wooded Waterfall

Painting waterfalls is simple, you just drag the fan gogh brush over the paper in the direction of the falling water! It is the surrounding rocks and foliage that will take the time, but using the credit card technique for the rocks will speed things up. If you keep the rocks on either side dark, the lighter falling water will stand out.

You will need

Plastic card
Brushes: foliage, fan gogh, spring foliage, large detail, medium detail, small detail, wizard
Colours: raw sienna, sunlit green, ultramarine, burnt umber, cobalt blue, country olive, midnight green, white gouache

1 Draw the scene.

2 Paint all the rocks with raw sienna, adding a little sunlit green to the one at bottom right. Paint ultramarine and burnt umber over the top with the foliage brush and scrape out texture with a plastic card (see page 24).

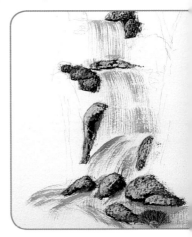

3 Use the fan gogh and a dry mix of ultramarine to drag down the texture of the water. Create the direction of the flow down the waterfall, then suggest the water spraying out in different directions at the bottom.

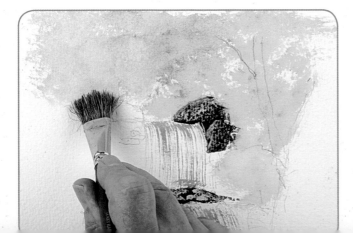

4 Paint a wash of cobalt blue in the centre of the background using the spring foliage brush, then stipple on sunlit green to begin creating the foliage.

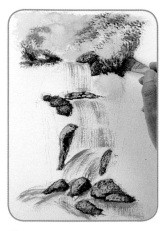

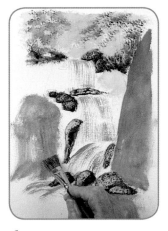

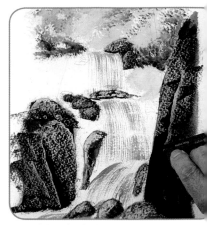

5 Continue stippling on the foliage with a strong mix of country olive.

6 Mix raw sienna and sunlit green and paint this as a background colour on the moss-covered rocks of the ravine.

7 Paint a dark mix of ultramarine and burnt umber over the rocks, and use the credit card rocks technique (see page 24), scraping out texture with a plastic card and leaving dark paint to create crevices and shadows.

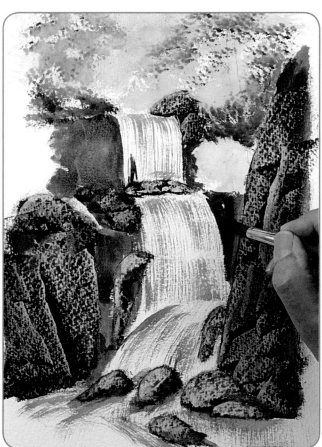

8 Use the large detail brush and a slightly lighter mix of ultramarine and burnt umber to define the rocky edges of the waterfall.

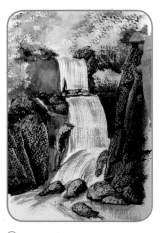

9 Stipple texture on to the trees and bushes using the spring foliage brush and country olive. The painting so far took me fifteen minutes.

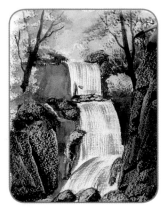 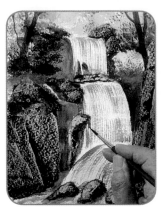

10 Use the medium detail brush and burnt umber and country olive to paint the tree trunks and branches. I was about twenty minutes into the project at this stage, which left me time to add some detail and refinements.

11 Change to the spring foliage brush and stipple midnight green over the rocky area to the left of the waterfall, to create bushes, then continue stippling on the right-hand side of the background trees.

12 Use the small detail brush and a mix of ultramarine and burnt umber to tidy up the edges of the rocks at the water's edge.

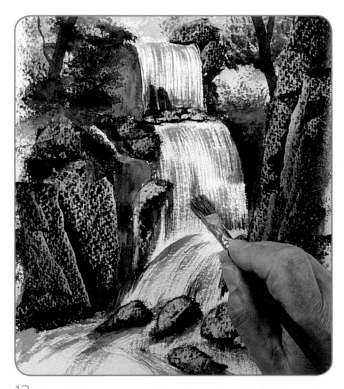

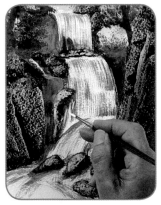

14 Use the small detail brush and white gouache to add sparkling highlights to the water.

13 Make a slightly greyer water mix from ultramarine and burnt umber and use a fairly dry wizard brush to add texture and variety to the water.

Opposite
The finished painting.

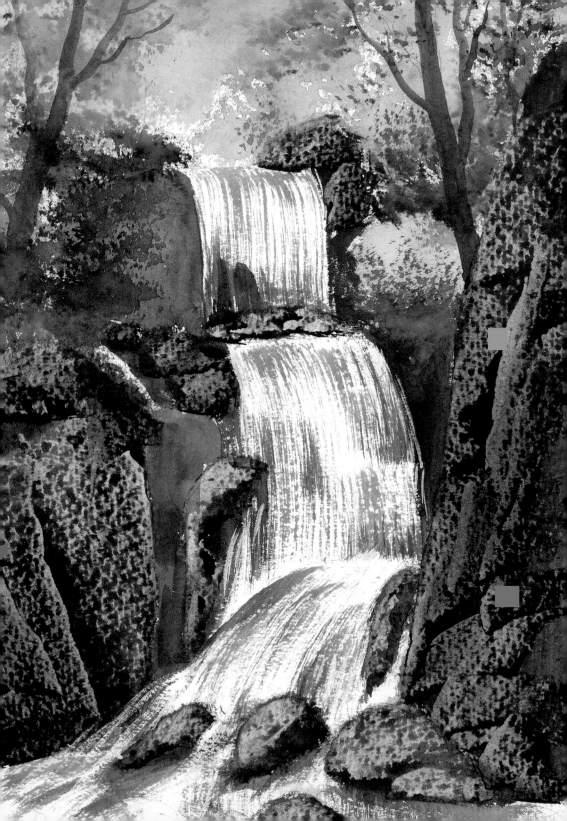

Lazy River

This hazy, lazy river flows slowly towards you, then it hits the rocks and goes crazy: with the stroke of a dry brush it becomes a raging torrent. I love the light on the water with the sparkling ripples and the dark silhouette of the tree trunks with the light behind them.

You will need

Masking fluid and brush
Plastic card
Brushes: foliage, spring foliage, golden leaf, medium detail, wizard, small detail
Colours: raw sienna, ultramarine, burnt umber, cobalt blue, cadmium yellow, midnight green, country olive

1 Draw the scene. Mask ripples in the water with masking fluid and a brush.

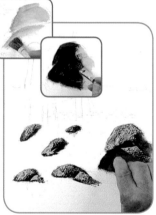
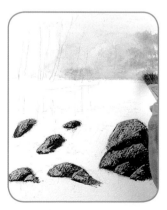

2 Paint the rocks using the credit card rock technique (page 24). Use the foliage brush to paint on raw sienna, then a dark mix of ultramarine and burnt umber, then scrape out texture using a plastic card.

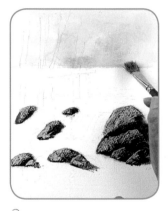

3 Paint a wash over the background with the spring foliage brush and cobalt blue, then stipple on cadmium yellow wet into wet. You should be around ten minutes in.

4 Mix cobalt blue and cadmium yellow and stipple this on to the background.

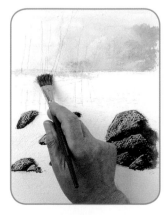

5 Stipple raw sienna in the distance behind the river bank.

6 Use the golden leaf brush and a mix of cobalt blue and midnight green to stipple foliage over the tree area in the background.

7 Change to the spring foliage brush and stipple on a darker mix of the same colours.

8 Stipple undergrowth on the river bank with a mix of country olive and midnight green. Allow to dry. You should be about fifteen minutes in at this stage.

9 Use the medium detail brush and a pale mix of country olive and midnight green to paint the tree trunks on the river bank. This stage can take some time.

10 Stipple midnight green over the trees to create foliage using the spring foliage brush. The painting so far took me around twenty minutes.

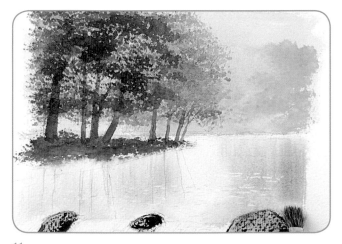

11 Wet the water area above the rapids with the wizard, then drag down varying pale washes of cobalt blue and cadmium yellow to create reflections of the foliage above.

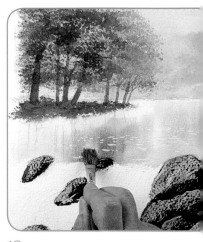

12 Mix midnight green and cobalt blue and drag this down to reflect the middle ground trees.

13 Paint the reflection of the river bank in the water with a dark mix of cobalt blue and midnight green. Dry.

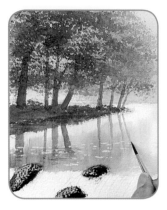

14 Use the small detail brush to paint reflections of the tree trunks with a mix of cobalt blue and midnight green.

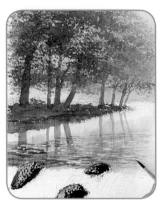

15 Use the same brush and mix to paint ripples across the calmer part of the river.

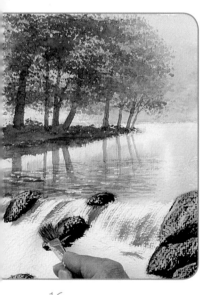

16 Change to the wizard and drag a dry mix of ultramarine and a touch of midnight green down the waterfall to create the flow of the water.

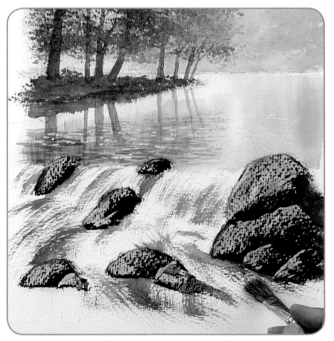

17 Continue painting the flow of the water further down the waterfall, making it go off in different directions as it crashes round the rocks. This should take you to around 30 minutes.

Opposite
The finished painting.

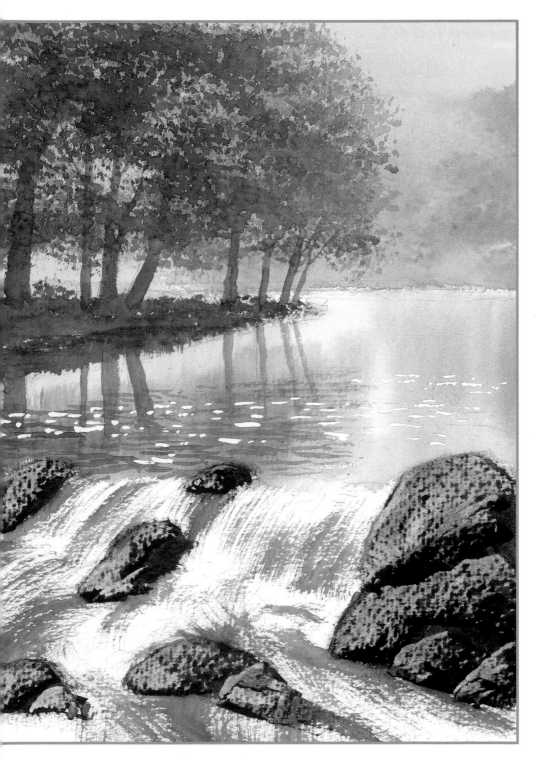

Stormy Sea

Painting the many moods of the sea could be a lifetime's work but you only have 30 minutes! This project is all about the power of the stormy sea pounding the rocks, shooting a plume of spray high into the air. The breaking wave in the foreground is closely followed by another one, ready to crash down on the rocks below.

You will need
Masking fluid and brush
Kitchen paper
Plastic card
Brushes: foliage, spring foliage, medium detail, wizard
Colours: raw sienna, ultramarine, burnt umber, midnight green, cobalt blue

1 Draw the scene.

2 Pick up masking fluid on kitchen paper and dab it on to the spray from the crashing waves.

3 Use a brush to mask drops of spray, the texture of the foam and distant wave crests. Allow to dry.

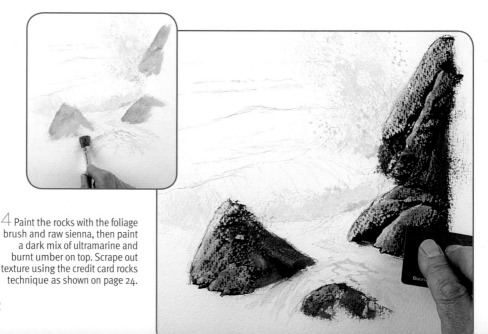

4 Paint the rocks with the foliage brush and raw sienna, then paint a dark mix of ultramarine and burnt umber on top. Scrape out texture using the credit card rocks technique as shown on page 24.

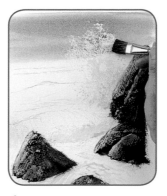

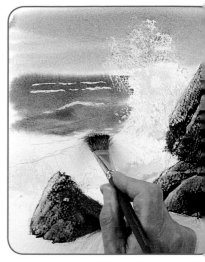

5 Wet the top of the painting with the spring foliage brush and clean water then drop in a pale wash of raw sienna for the sky.

6 While this is wet, paint a strong mix of ultramarine and burnt umber from the top downwards.

7 Paint the distant sea with a mix of ultramarine and midnight green, then change to a greener mix coming forwards. You should be about fifteen minutes in at this stage.

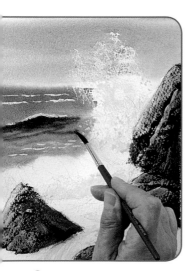

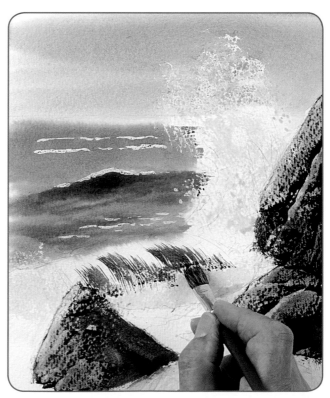

8 Working wet into wet, use the medium detail brush and a much stronger mix of the same colours to darken under the crest of the wave and paint texture.

9 Use the wizard and the same mix to paint the texture of the water rolling over the wave in the foreground.

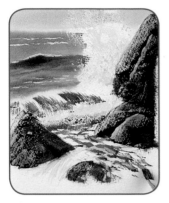

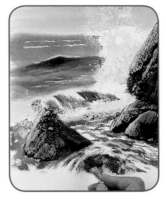

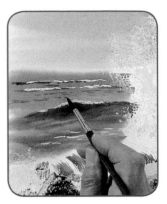

10 Paint the water between the rocks using side-to-side strokes as for choppy water (see the top of page 32).

11 Paint the water pouring down between the two foreground rocks with downward strokes, using a dry mix to create texture. You should be about twenty minutes in at this stage.

12 Change to the medium detail brush and a dark mix of midnight green and ultramarine and paint shadow under the masked distant wave crests.

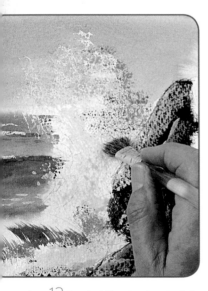

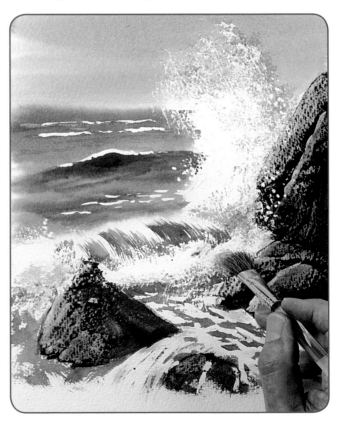

13 Use the foliage brush and cobalt blue to stipple shadows in the foam over the masking fluid. Dry.

14 Rub off the masking fluid with clean fingers. Stipple shade and texture on the foam with the foliage brush and cobalt blue.

Opposite
The finished painting.

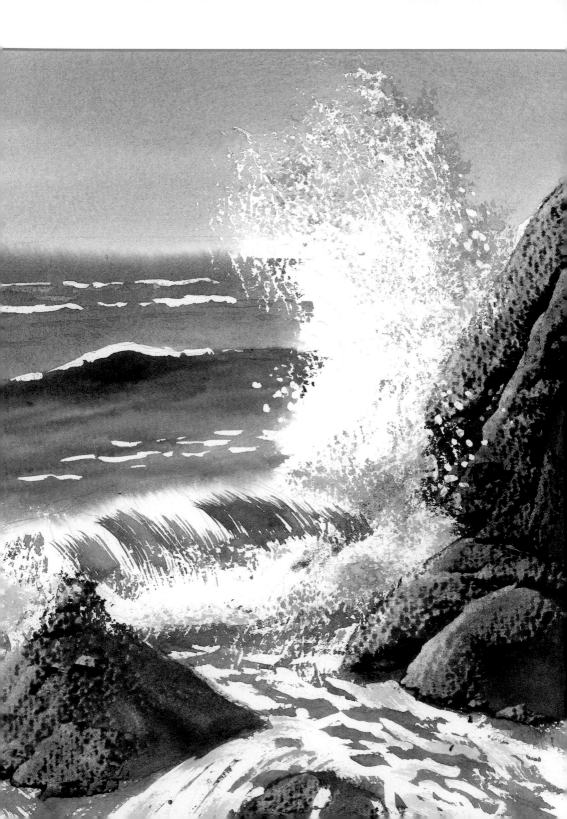

Cliffs

This is a classic example of how to paint cliffs receding into the distance, creating a sense of depth. The sunlight sparkling on the incoming evening tide adds a romantic glow to an otherwise simple composition. This is all about tonal values, or light and dark to you and me. The light blue cliffs are in the far distance and as the cliffs come closer to you, they become darker. The dark of the headland and the beach are in stark contrast to the light on the water.

You will need
Masking fluid and brush
Kitchen paper
Brushes: spring foliage, medium detail, large detail, foliage
Colours: raw sienna, cobalt blue, permanent rose, burnt sienna, burnt umber

1 Draw the scene first.

2 Use masking fluid and a brush to mask the sun highlights on the sea, down the centre, the waves rolling in and the highlights in the shingle.

3 Dip kitchen paper in masking fluid and dab texture on to the foam in the foreground.

4 Wet the sky area with the spring foliage brush and clean water, then paint on a pale wash of raw sienna.

5 Working wet into wet, paint a wash of cobalt blue and permanent rose in horizontal strokes across the top of the sky and blend it downwards. Dry.

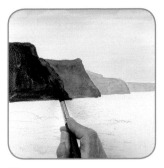

6 Use the medium detail brush and the same mix of cobalt blue and permanent rose to paint the distant cliff. Dry. Paint the next headland coming forwards with a stronger mix, with a little burnt sienna. Dry.

7 Use the large detail brush to paint the next cliff coming forwards with cobalt blue and burnt sienna.

8 Paint the nearest cliff with a mix of burnt umber and cobalt blue. Dry. You should be about ten minutes into your painting time.

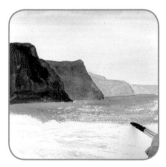

9 Use a mix of cobalt blue and burnt sienna to paint the distant sea, going over the masked ripples. The brush should be fairly dry, leaving speckles of paper to suggest sparkles.

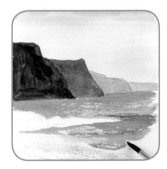

10 Make a stronger mix of the same colours and paint the foreground sea.

11 Use a slightly lighter mix at the edge of the sea, and paint beyond some of the masked surf. You should now be around fifteen minutes into the painting time.

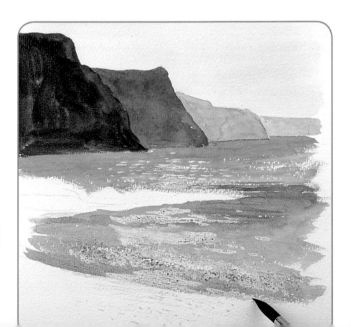

12 Mix cobalt blue and burnt umber and paint shade under the wave crests in the foreground sea. Add ripples.

13 Mix ultramarine and burnt umber and use the medium detail brush to paint the groyne, which should be darker than the darkest cliff.

14 Paint the beach with the foliage brush and raw sienna.

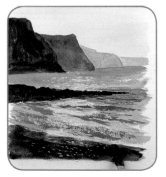

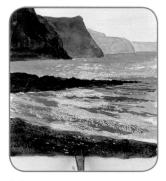

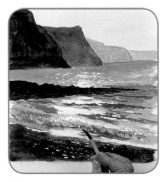

15 Add burnt sienna and ultramarine to the raw sienna and go over the masked shingle. Dry. You should be about twenty minutes into the painting time.

16 Make a darker mix of the same colours and stipple it on to create texture on the shingle. Dry.

17 Remove the masking fluid with clean fingers. Mix cobalt blue with a little burnt sienna and use the medium detail brush to paint shade and texture on the white foam.

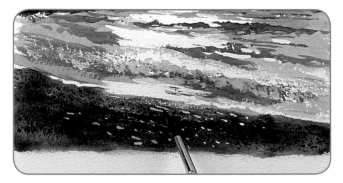

18 Paint a wash of raw sienna over the highlights on the shingle.

Opposite
The finished painting.

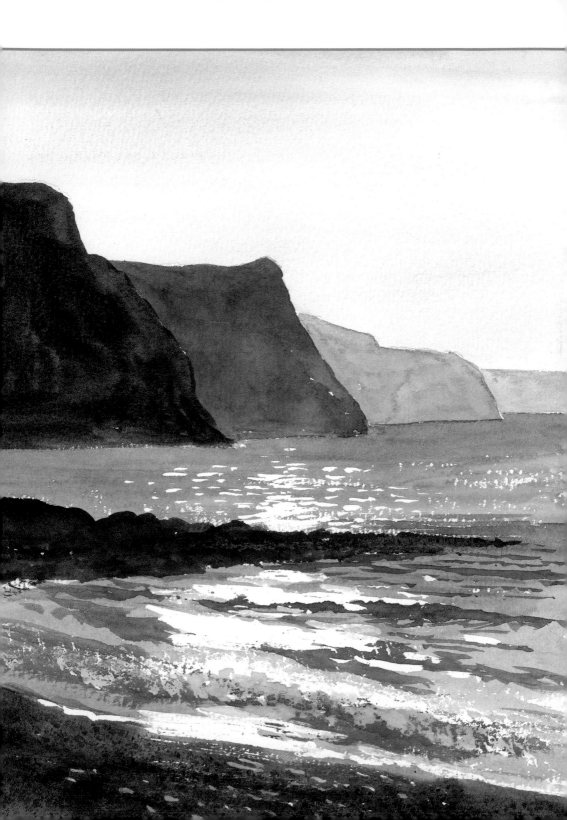

Fisherman

As a boy, I was a keen fisherman, and my dream was to fish from a boat on a still morning as the sun rose over a misty lake. One day maybe, but in the meantime I will have to content myself with a painting instead. The good thing about this project is that it will only take 30 minutes to relive the dream again.

You will need

Masking fluid and brush
Coin and kitchen paper
Ruler
Brushes: golden leaf, wizard, medium detail, small detail, half-rigger
Colours: raw sienna, permanent rose, shadow, burnt sienna

1 Draw the scene. The painting time starts now! Use masking fluid and a brush to mask the sparkles on the water beneath the sun.

2 Use the golden leaf brush to wet the whole painting. Paint a wash of raw sienna down from the top of the painting, then from the bottom up.

3 Add permanent rose to the raw sienna to darken it a little and paint wet into wet down from the top and up from the bottom again.

4 Wrap a small coin in a double layer of kitchen paper and use this to lift out colour for the sun directly over the masked sparkles.

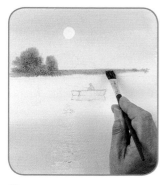

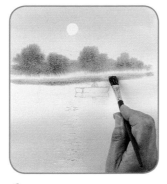

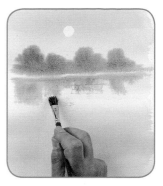

5 Working wet into wet, use the wizard and a mix of shadow and burnt sienna to paint the distant trees and the waterline.

6 Leave a little gap, then paint a straight line below the waterline to begin the reflection.

7 Drag down the colour, going over the boat, to create the reflection of the trees.

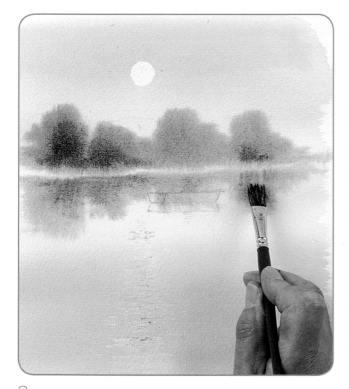

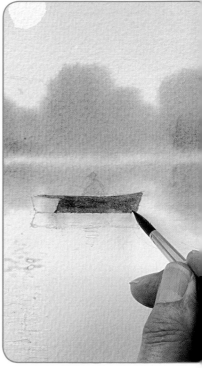

8 Use a strong mix of the colour shadow to paint texture into the distant trees and their reflection. Dry the painting.

9 Change to the medium detail brush and paint a mix of shadow and burnt sienna over the boat as shown. You should be around fifteen minutes into the painting time by now.

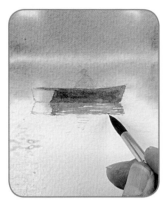 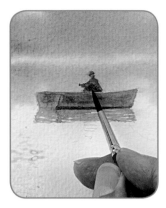 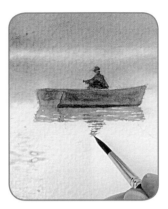

10 Paint the reflection of the boat, making sure it is broken by little gaps to suggest ripples.

11 Use the small detail brush and a light mix to paint the stern of the boat, then a stronger mix to paint the boat at the waterline, and the fisherman.

12 Add a rippled reflection of the fisherman.

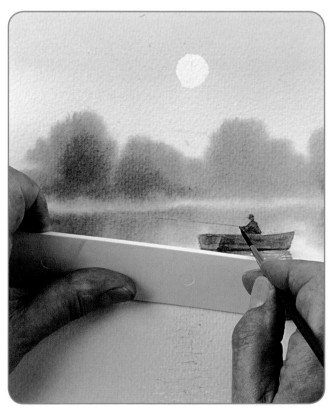

13 Use the half-rigger and the darker mix to paint the fishing rod, using a ruler to help you. Prop the ruler against your finger and run the ferrule of the brush along the edge.

Opposite
The finished painting.

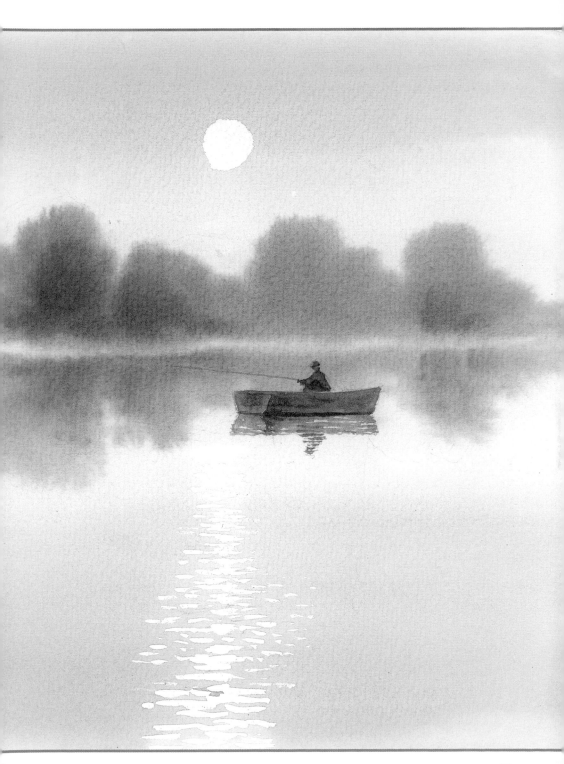

Misty Lake

The very thought of painting mist on a lake can send some artists into a panic, but if you follow the few steps in this project and use kitchen paper as shown, you will find it simple and effective. The other key to success when painting this misty scene is the use of the wet into wet technique to capture the out-of-focus trees and reflections across the lake. The foreground, in contrast, is quite strong, crisp and bold.

You will need

Masking fluid and brush
Kitchen paper
Brushes: golden leaf, foliage, fan gogh, half-rigger, small detail, spring foliage, medium detail
Colours: raw sienna, ultramarine, cobalt blue, midnight green, country olive, sunlit green, midnight green, burnt umber, burnt sienna

1 Draw the scene. Your painting time starts after this.

2 Mask the trees and branches of the silver birch using masking fluid and a brush.

3 Wet the whole area of the sky and water with the golden leaf brush and clean water, then paint a pale wash of raw sienna in the middle.

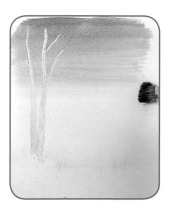

4 Paint a wash of ultramarine, starting at the top of the sky and fading down into the raw sienna.

5 Start another wash of ultramarine from the bottom of the water area upwards, blending into the raw sienna as before.

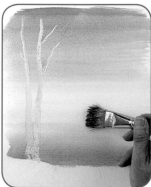

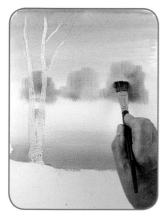

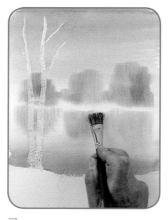

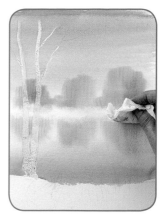

6 While the background is still wet, paint the distant trees with the foliage brush and a mix of cobalt blue and midnight green.

7 Leave a space at the waterline and drag down the same colour to create the reflection of the trees in the water.

8 Use kitchen paper to lift out colour to reinstate the lighter band on the waterline. The painting so far should have taken around ten minutes.

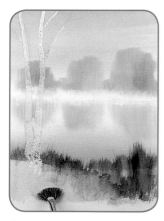

9 Use the fan gogh and midnight green to paint grasses at the water's edge in the foreground, then paint a lighter mix of country olive, raw sienna and sunlit green below this. Dry.

10 Paint grasses over the top of this area wet on dry with country olive.

11 Change to the half-rigger and use midnight green to paint a clump of bullrushes in the bottom right-hand corner.

12 Use the small detail brush and burnt umber to paint heads on the bulrushes. You should be around fifteen minutes into the painting time.

13 Stipple foliage at the top of the silver birch with the spring foliage brush and country olive. Dry and remove the masking fluid.

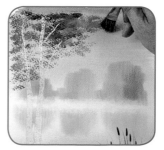

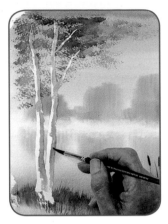

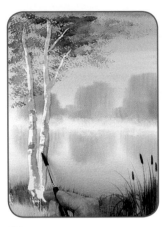

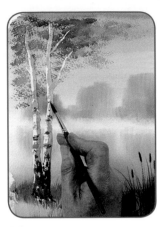

14 Use the medium detail brush and a grey mix of cobalt blue and burnt sienna to paint shade on the right-hand side of the silver birch trunks and branches. Dry. The painting so far should have taken about twenty minutes.

15 Make some horizontal marks in the bark with a slightly stronger mix.

16 Make a dark mix of burnt umber and ultramarine and make marks over the trunk: thick patches at the bottom and horizontal marks further up the bark.

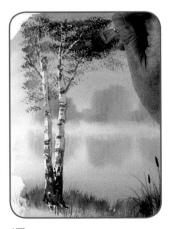

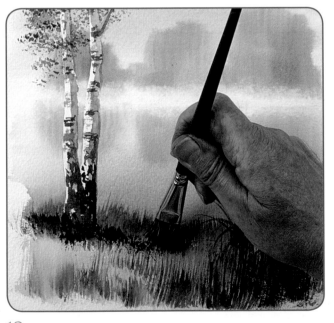

17 Use the spring foliage brush to stipple a dark mix of midnight green over the silver birch foliage.

18 Stipple undergrowth at the base of the silver birch with dark midnight green to place the tree in the landscape. That should complete your half-hour painting time.

Opposite
The finished painting.

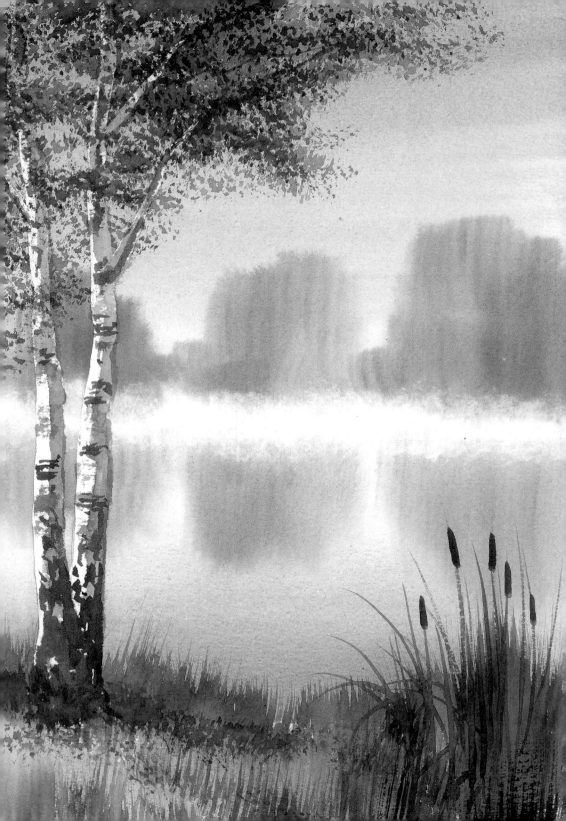

Fishing Boat

You do not need to know all about boats to be able to paint them. This project seems complex, but the shapes are quite simple; just copy and paint what you see, not what you think you see. The reflection of the boat repeats the colour mixed for the boat, so paint the boat and the reflection at the same time. A flat brush makes the painting of the ripples easier.

You will need

Brushes: large detail, 19mm (¾in) flat, medium detail, small detail, 13mm (½in) flat
Colours: ultramarine, cadmium red, burnt sienna, burnt umber, raw sienna, cobalt blue, midnight green

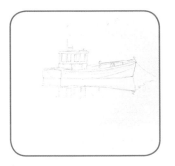

1 Draw the boat and its reflection.

2 Wet the background with the large detail brush, leaving the boat and its reflection dry. Paint a wash of ultramarine up from the bottom to the reflection. Start at the top of the sky in the same way and bring the wash down to the boat.

3 Before the background dries, wet the 19mm (¾in) flat brush and squeeze out the excess water. Use the damp brush to lift out ripples below the boat.

4 Use the large detail brush to paint the windows of the wheelhouse and its reflection with ultramarine.

5 Paint the gunwale facing us with a pale mix of cadmium red and ultramarine, then paint the inner gunwale with a stronger mix.

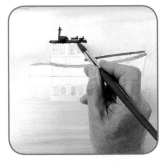

6 Paint the top of the wheelhouse with burnt sienna and ultramarine. The painting so far should have taken around ten minutes.

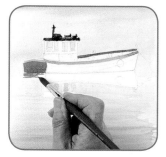

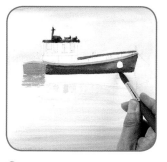

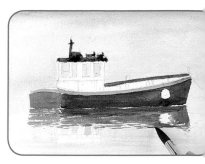

7 Make a fairly light mix of ultramarine with a touch of burnt umber and paint the stern of the boat and the broken, rippled reflection.

8 Paint the side of the boat with a stronger mix of the same colours, changing to a still stronger mix along the waterline and under the gunwale.

9 Add a little more burnt umber to the mix to paint the reflection, leaving some light paper for ripples. Continue with a lighter reflection lower down. You should be around fifteen minutes into the painting time.

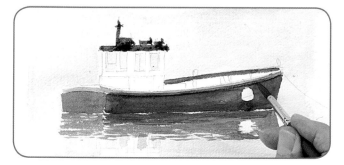

10 Use the medium detail brush and cadmium red to paint a darker line at the bottom of the gunwale facing us.

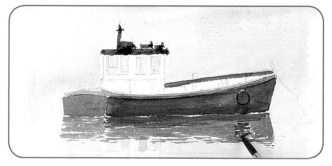

11 Paint the circular fender and its reflection with a strong mix of cadmium red.

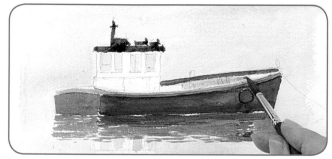

12 Mix raw sienna with a little cobalt blue and paint the strip of the boat's inside that is visible.

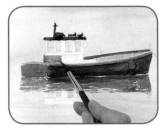

13 Still using the medium detail brush, paint the end of the wheelhouse with ultramarine.

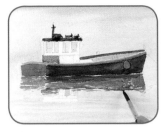

14 Make a pale mix of cadmium red with a little ultramarine and paint the reflection of the gunwale. Break it up for a rippled effect. Dry.

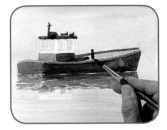

15 Paint the shadowed side of the wheelhouse with ultramarine and burnt umber. Use the same mix to paint a block and post and their rippled reflection. You should be about twenty minutes into the painting time.

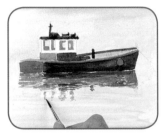

16 Use the small detail brush to paint the insides of the wheelhouse windows with a pale mix of burnt umber and ultramarine, then suggest their rippled reflection in the water.

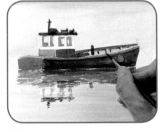

17 Paint the rippled reflection of the top of the wheelhouse with a brown mix of ultramarine and burnt sienna. Use the same mix to paint detail inside the boat.

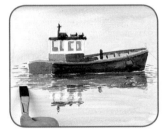

18 Use the 13mm (½in) flat brush to paint small ripples around the boat with ultramarine.

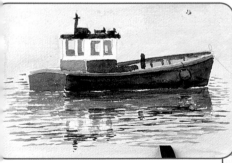

19 Paint more ripples coming forwards with a pale mix of midnight green and ultramarine. Change to the 19mm (¾in) flat and paint larger ripples with a bluer mix in the foreground.

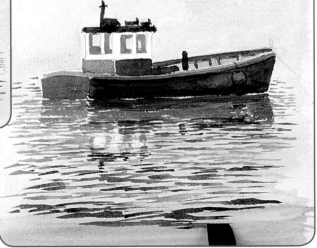

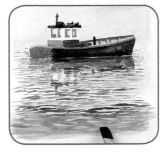 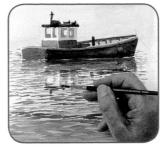 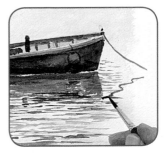

20 Paint the foreground rippled water with a paler mix and larger movements of the brush.

21 Use the small detail brush and a mix of cobalt blue and burnt umber to paint the shaded side of the top of the wheelhouse, and its reflection.

22 Paint the mooring line with a dark mix of burnt umber and ultramarine, then paint the reflection with a wiggled line.

The finished painting.

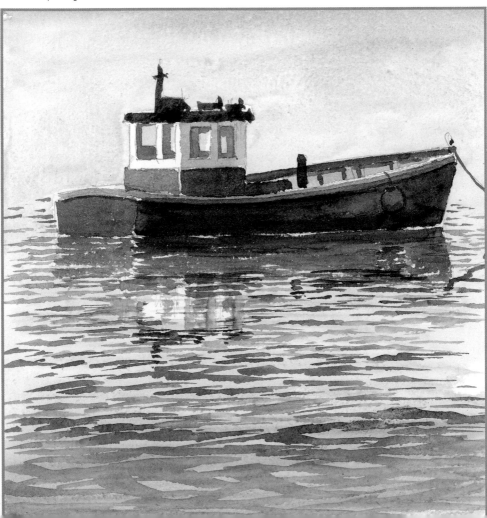

Sunset Estuary

There can't be many more pleasurable moments in life than watching the sun setting over water, and by painting the sunset, you get the two magical moments for the price of one!
Painting the sea can be time-consuming but here it can be achieved fairly quickly, and you will be rewarded with a stunning and realistic sunset.

You will need

Masking fluid and brush
Ruler
Small coin and kitchen paper
Brushes: spring foliage, wizard, medium detail
Colours: cadmium yellow, raw sienna, permanent rose, cobalt blue, shadow, burnt umber, ultramarine

1 Draw in the headland and rocks on the right of the painting. Your painting time starts now. Mask the rippled reflection of the sun in the water with masking fluid and a brush.

2 Use the spring foliage brush to paint clean water over the whole painting, then paint a wash of cadmium yellow and raw sienna over the sky from the top down, and a reflection of this colour around the masked reflections.

3 While the painting is wet, paint permanent rose at the bottom of the sky.

4 Paint a reflection of the permanent rose band at the top of the water, still working wet into wet, then add a band at the top of the sky and blend it down with horizontal brush strokes.

5 Apply a wash of cobalt blue at the top of the sky and blend this down into the pink.

6 Still working wet into wet, paint clouds with the colour shadow.

7 Wrap a small coin in two layers of kitchen paper and lift out a circle for the sun, making sure it is directly above the masked reflection.

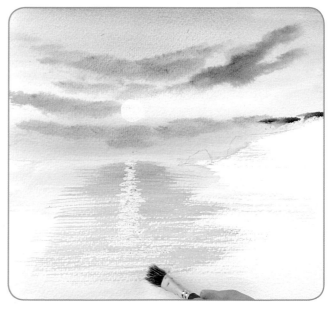

8 Use the wizard to paint a strong mix of cadmium yellow with a little permanent rose over the area of the sun's reflection, going over the masking fluid. You should be about fifteen minutes into the painting time now.

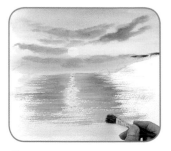

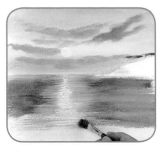

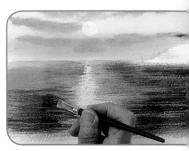

9 Make a deeper, pinker mix of the same colours and paint this over the bright central band, especially at the edges. Dry.

10 Make a strong, dark mix of permanent rose and shadow and paint this over the sea area with horizontal strokes, using a fairly dry brush.

11 Strengthen the paint mix and continue painting across the sea. Dry.

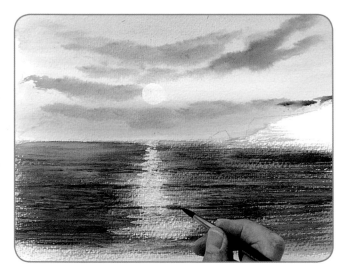

12 Use the medium detail brush and a darker mix of shadow and permanent rose to paint horizontal ripples to suggest waves coming forwards.

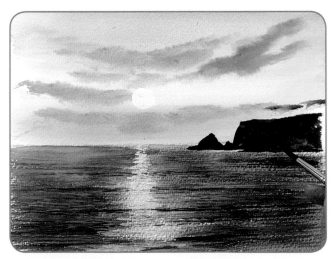

13 Paint the headland and rocks with a very dark mix of burnt umber and ultramarine.

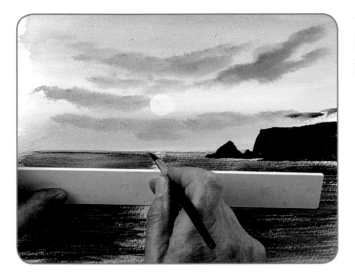

14 Prop up a ruler against your fingers to help you create a straight horizon. Load the brush with raw sienna and permanent rose and run it along the ruler.

The finished painting.

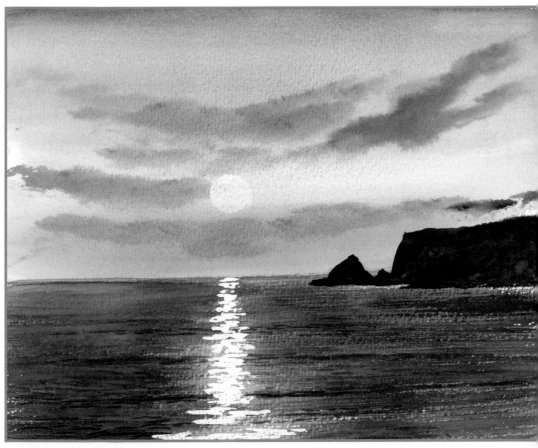

Index

Woodland Stream
Both still and rippled reflections add to the impact of this atmospheric woodland scene.

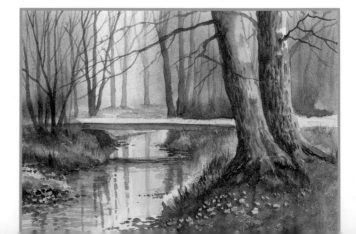